THE BIG PAINTING CHALLENGE

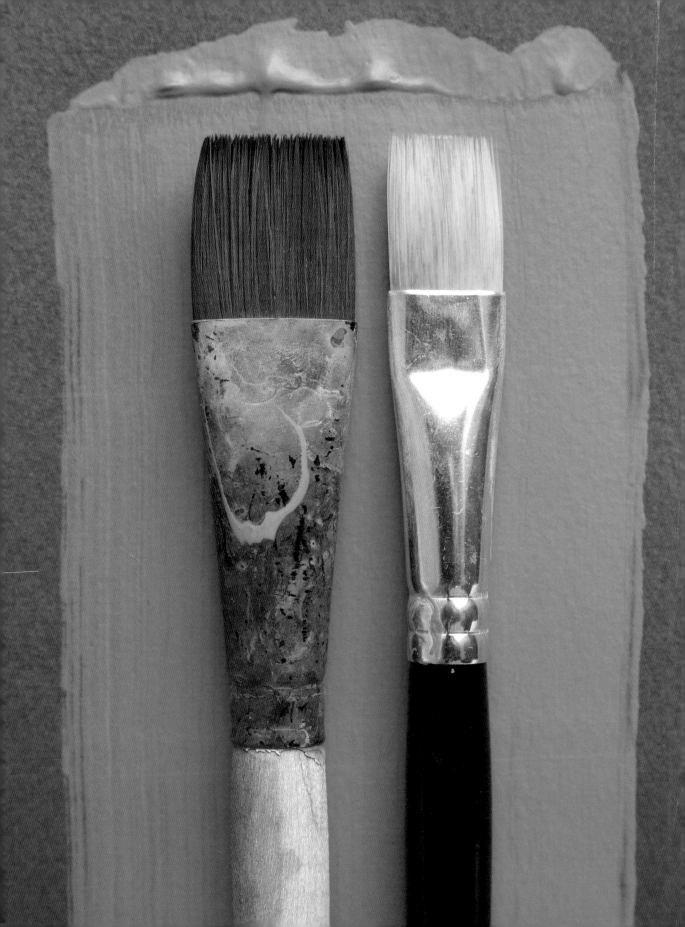

THE BIG PAINTING CHALLENGE

A practical guide to painting and drawing

BOOKS

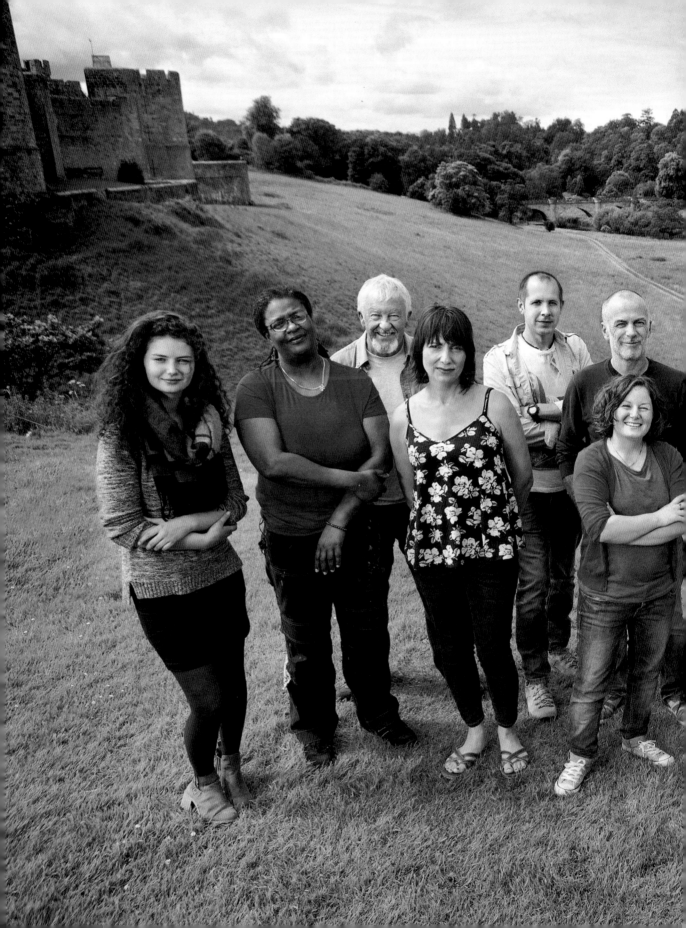

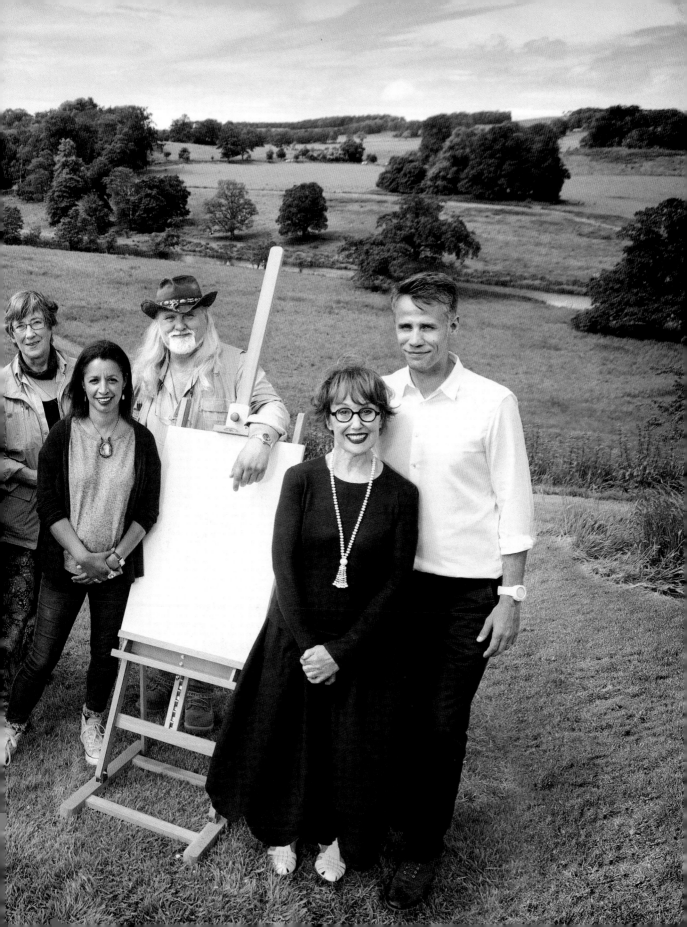

Taking up painting, especially from life, is a marvellous way of really living in the moment, learning to savour the here and now like a gourmet. Painting uses the whole of you, stretching you mentally, physically and emotionally. So in the process of painting you feel fully alive. It can even make you happy!

This book, with its gorgeous colours and encouraging words, will tempt you to have a go. When you do, just dive in. Make some marks, then some more. Whatever you have made the marks with – a paintbrush dipped in paint, a matchstick dipped in shoe polish, a biro or a pencil – you are drawing, i.e. pulling something across a surface, leaving your mark. You may enjoy just the marks themselves and spend a while experimenting, making them look joyful or sad, fast or slow, light or heavy, near or distant. Or you may want the marks to impart information about something you have seen – a person, a landscape, the clutter in the kitchen. It is difficult, attempting to represent what the world looks like, but very exciting to try and so absorbing. I am sure that is why even immensely busy people, such as Winston Churchill and HRH The Prince of Wales, make time to make art. If they can, we can.

You needn't worry too much about perspective and proportion at first. Lots of great works of art contain elements that are 'wrong' from a strictly analytical point of view. But they are still great works of art. (Art is a very complex concept.) They may express a wonderful feeling, use breathtaking combinations of colour or intentionally use distortion to say something otherwise unsayable. Professional artists recognized the worth in an untaught Cornish fisherman, Alfred Wallis, who began painting the scenes he loved on bits of misshapen cardboard, in a naive but poetic and utterly charming way. His work continues to be enjoyed in many public galleries and proves that we can all be artists, every single one of us. Just begin!

Daphne Todd

My father was an artist. Every day, when I returned home from school I would run to visit him in his studio, a room bursting with canvases, brushes and piles of old paint tubes. I loved being there. I would watch him closely as he created his own paintings and learn from him, like a young apprentice. I've never had a better teacher.

Occasionally I would show him something I was working on and he'd say, 'Let me give you this little tip, it's going to save you about ten years of struggle!' Then he would tell me how to mix a certain colour or capture a trick of perspective. Sometimes I disliked having to change an image I was pleased with but, frustratingly, he was always right. The painting was invariably improved. Working with amateur artists on *The Big Painting Challenge* was an opportunity to pass on some of that privileged advice, along with the lessons I've had to teach myself over many years working as an artist.

When I start a new painting it feels to me like opening a trapdoor; I never know exactly what I'm going to find or what I'll end up creating. Developing and crafting an image is an exhilarating experience but it's one in which every step, every brushstroke, matters.

Before you even touch the canvas, scrutinize your subject. There are many ways to create a successful painting but I find it helps to think first about your overall composition, scale and perspective. Immediately engaging with and not ignoring these fundamental elements can help. The resulting canvas will, I'm sure, communicate what it is you want to say all the more clearly.

Painting, though, is not just about structure and technique. It's also about emotion, energy, unexpected ideas and points of view; painting is magic. From out of a blank sheet of paper you can conjure up new worlds. You can put a line around life and colour it in – whichever way you choose. But it's not always easy. Spells must be practised, colours experimented with and mistakes will need to be made. The one guarantee with creating paintings is that there's always plenty of rubbing out to be done. So don't be disheartened. The best artistic advice I ever had was to never be afraid of taking a risk; the worst that's going to happen is you'll need to start your canvas again. So I recommend you go and make some mistakes. Open that trapdoor, break out your sketchbooks and discover all the wonderful paintings still waiting to be created.

Lachlan Goudie

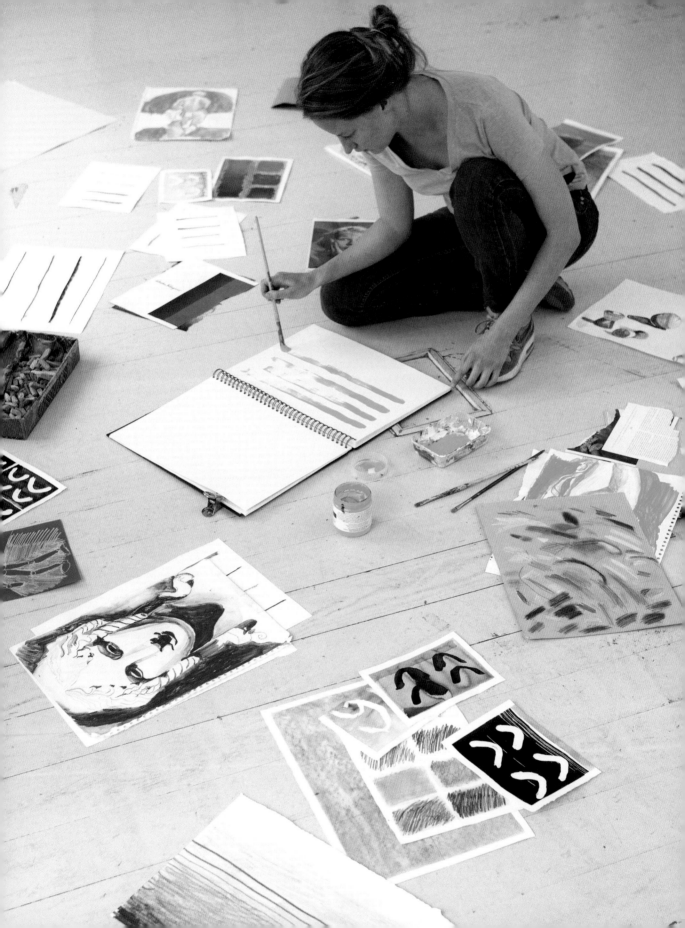

CONTENTS

Why Paint?

Painting and drawing can help us to understand the world in terms of shape, space, colour and light. This is incredibly useful for any design- or art-based career but it's also the basis for a hobby we can all enjoy.

Unfortunately, for many of us our creative urges are constantly sidelined as we are busy working, looking after family, cleaning the house or doing countless other chores. Wanting to express our own creativity through something like art can seem frivolous and indulgent to many of us, and we're held back by nagging doubts – 'What if I'm really bad and make something terrible and embarrass myself?' or 'That teacher said I was awful at art and I'm sure she was right, so I won't even give it a go even though I really want to.'

But anyone can be creative and we should all be encouraged to explore that side of us.

In a busy age of computers, smartphones, email and multimedia, in which our attention is constantly being diverted, the simplicity of concentrating intently on one subject in order to draw or paint it can be a much needed meditation.

In contrast to the virtual world, painting or drawing is a direct act – it is a tactile experience in which we hold the materials in our hand and make marks that we can rub out, blend and otherwise manipulate directly. We make a mess, our hands get covered in graphite, pastel dust or paint, and we are left with the tangible fruit of our labours at the end.

I have taught painting and drawing for many years and people tell me every week how quickly the time passes when they are involved in creative activity. They forget about work and all the things that have been consuming their attention, and they can just be there with their subject and their artwork. Focusing completely on creating art is calming, satisfying and immersive.

It is also fun, let's not forget that. Paint is squelchy, colourful and messy, and appeals to the child in us that wants to play, make things and express ourselves. We get to choose the subject, the style, what aspects to focus on and what to leave out. We can be subversive or controversial if we want to be, or we can just respond to what we think is pretty and paint our favourite cup or our dog, just because it makes us happy.

Painting and drawing take us out of our own heads and fix our focus clearly

and sharply on the world around us. We forget about our lives, all the things that need to be done and simply concentrate on the subject we are working on and our own representation of it. All these things make art great for relieving stress and anxiety. And you never know, at the end you might even be left with something that you quite like!

So what do you need to get started?

You can start drawing with only a few scraps of paper, a pencil and a rubber. Painting requires a little bit more: some paints and brushes, obviously, and depending on the kind of paint, you might need to add solvents and oils.

But let's start simply. If you want to try making visual art, drawing is the best place to begin. And for that, all you really need is something to draw with, something to draw on, and a little bit of time and space …

SOMETHING TO DRAW WITH

Anything that leaves a mark on paper could be considered a drawing material. We all have pens and pencils lying around the house and you can get started with what you already have.

SOMETHING TO DRAW ON

You can use whatever you have around the house – a couple of sheets of A4, a favourite notebook or diary. It can also be fun to draw on found materials such as the pages of fashion magazines or scraps of card that you have lying around the house.

A SUBJECT

If you are starting at home you could set up a still life on the kitchen table using fruit and crockery, or you could draw your shoes, your hand or your own face in the mirror. If you feel a little more adventurous you could work from the landscapes around you or draw the sugar bowl on the café table while you are waiting for your friend.

SOME SPACE

You can draw on a sketchbook resting on your knee, or at a table or desk. Most people prefer working somewhere with lots of natural light. It's useful if there is a space or table in your house that you can dedicate to painting and drawing (meaning that you don't have to be fastidious about clearing up at the end of the day) but, if that's not possible, don't worry. All artists have to work with the resources available to them at the time, and sometimes having to work on a smaller picture than you might like or having to work outside of the house can be a good thing, as it pushes you out of your comfort zone.

SOME PATIENCE

Don't expect to be amazing from the start. Give yourself permission to play and to have a couple of disasters at the beginning without getting angry. Start simply, drawing simple objects and just trying to get to grips with the outline and basic shading, and try not to focus too much on outcome at first. Focus more on indulging your creative urge, enjoying the process of responding to the world around you and making those first few tentative marks.

THE BASICS

Basic Equipment

This section covers the general equipment that you might need when making art. The artistic mediums themselves are covered in more detail later in the book.

BRUSHES

In general the thicker the paint that you are using, the stiffer and more robust a brush you will need.

If you use a very soft brush with thicker paint, it will tend to clog and it won't be easy to transfer the paint from the brush to the painting. When using heavy-bodied paints such as acrylics and oils, you need brushes with stiffer bristles that are strong enough to work the thick paint. Watercolours are thin and watery, so they drip easily. For this reason it's best to use soft-bristled brushes because they will hold and transfer watery paint well.

As well as considering the strength of the bristles (i.e. does the brush feel soft and smooth to the touch or hard and stiff?), you also need to consider the shape of the brush.

Brushes come in three main shapes: rounded end, square end and pointed. Each shape leaves different kinds of marks on the page.

DRAWING MATERIALS

There are many types of drawing materials but the main ones are pencils, graphite sticks, drawing pens, pastels, coloured pencils, pastel pencils, charcoal sticks and charcoal pencils.

Accompanying materials include pencil sharpeners and cloths for preparing surfaces.

As well as normal stiff, sharp rubbers there are putty rubbers, which are sometimes used with charcoal and softer materials. These are softer and can be pulled apart and shaped for precision. It's good to have both large and small rubbers to hand, depending on the scale of the work and the size of the marks you are making. For small marks you can get pointed retractable rubbers or you can just use the rubbers on the ends of good-quality pencils.

Get into the habit of having both large and small rubbers on you. Small rubbers can be used as mark-making tools in themselves.

SQUARE

ROUNDED

POINTED

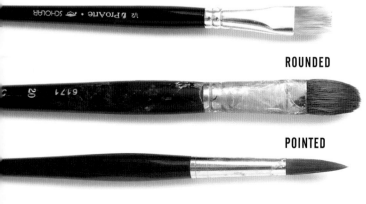

POINTED

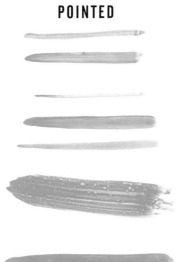

You can choose whether or not to make the individual brush marks/strokes prominent. If you like brush marks then it's a good idea to understand the different-shaped marks that brushes can leave. I like texture and brush marks so I blend very little. I also tend to use round-ended brushes as I think they leave a less harsh mark than square-ended brushes. You may prefer the look of a mark left by a square-ended brush.

SQUARE

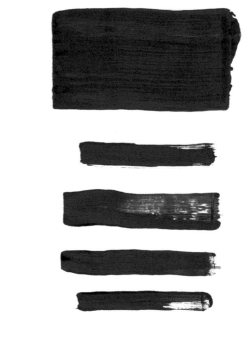

ROUNDED

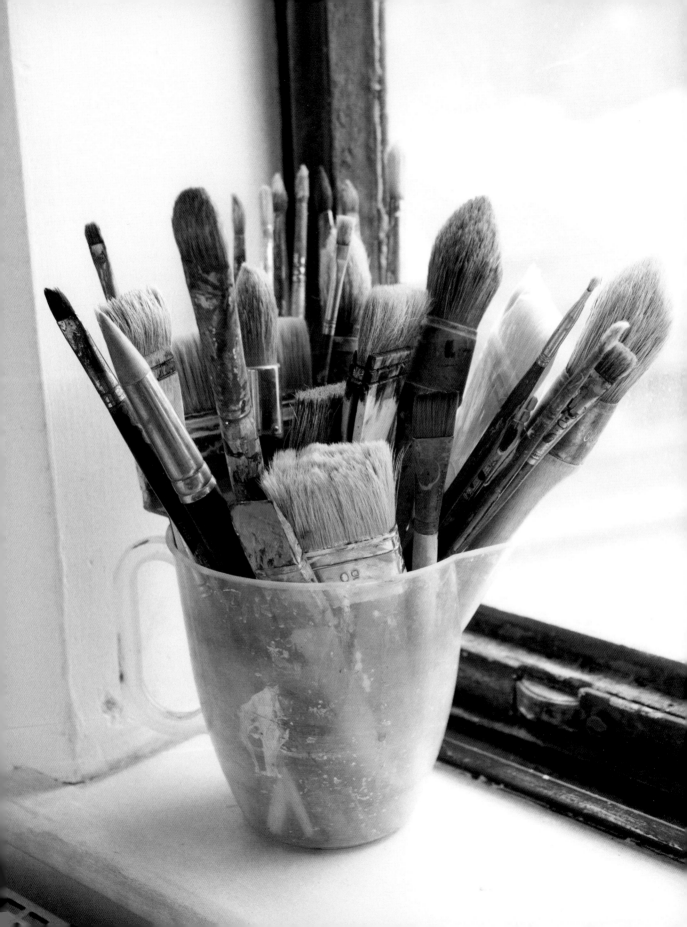

EASELS

Easels can be really helpful as they enable you to prop up a work and see it straight on instead of flat on a table. When you are working on a horizontal surface, your view of the work is slightly distorted as the top will be further away from you than the bottom. This can result in a painting or drawing looking quite different from what you intended when you finally hang it upright.

Easels come in wood and aluminium in varying sizes and qualities. They are generally adjustable so that you can alter the height at which you are working. This is important as you should be as comfortable as possible. Often, adjusting the easel so that the canvas or paper is just a few inches higher or lower can make all the difference and, as a result, can help unlock the creative flow.

Before you start, make sure that your easel is at the right height, you have a comfortable place to sit or stand and you are positioned well in relation to your subject. You should be able to see all of it clearly without having to crane your neck, twist your body or completely turn away from your canvas. Make sure you can see both your subject and your painting at the same time and that your materials are all in easy reach from the start.

Artist's boards

If you are using paper but you would like to work upright on an easel, you need to tape the paper to a stiff surface so that it will stand up.

Artist's boards are made of wood, medium density fibreboard (MDF) or stiff card. However, if you are working with wet materials, wood is best, as cardboard will degrade when in contact with water. You can get boards in a variety of materials and sizes from most art shops.

Board can also be a painting surface in itself like canvas or paper. Boards used as surfaces will usually need to be primed and prepared with much more care, attention and expense than the kind of backing board I am talking about here.

PAINTS

There are many different types and grades of paints available, from cheap ranges for kids and students to expensive professional-quality ranges.

The main difference between cheap and expensive paint is the colour intensity and permanence.

Intensity is a question of how much pigment is used. The more pigment (the base material that gives paint its colour), the richer and more intense the colour. Pigments are an expensive component of paint – for instance, ultramarine pigment is made from lapis lazuli, a semi-precious stone – so less pigment is used in cheaper paints. Also, some pigments can be difficult to refine, which makes colours that use those pigments more expensive.

Permanence is how long the colours remain at their initial intensity. Professional-quality paint is designed and tested to give high permanence so that colour intensity does not decrease or degrade over time. However, permanence

also depends on other factors such as exposure to sunlight and the nature of the pigments used. Fluorescent colours tend to have low permanence, with their initial glowing intensity degrading fairly quickly, whereas other pigments will remain unchanged for centuries.

Permanence should not be of much concern to the beginner; also the different intensities and exact shades between cheap and expensive paints are not usually obvious when you are starting out. If you find you like painting and start really getting an eye for colour then that's the time to start spending more money.

PALETTES

A palette is a space to mix colours before adding them to the surface of your painting. You can test the colours you have made on scrap paper before transferring them to the painting itself.

Palettes for acrylic

An acrylic paint palette can be made out of almost any non-absorbent surface, for example a plate or washed-out plastic takeaway box. However, I would strongly recommend investing in a **stay-wet palette**. They are not too expensive and are available from most art shops. They are a shallow tray in which you put a layer of damp absorbent paper or tissue, followed by a thin non-absorbent layer similar to tracing paper. This gives you a dry surface that is cool to the touch and keeps the paint from drying too quickly on the palette. This really helps, especially if you are painting outside or in hot places where small amounts of mixed colour will otherwise dry very quickly.

Stay-wet palettes also make cleaning up fairly simple as you just peel off the layers of wet tissue and film and throw them away.

Palettes for oil

Oil-painting palettes are generally flat and have a thumb-hole for ease of holding. You support the palette underneath with the palm of your hand and your thumb goes through the hole to steady the palette on top.

Oil paints don't dry quickly so there is no need for a stay-wet palette. The main choice you have to make is between a pad of disposable palettes or something that you will keep and scrape down at the end of the day.

I find the disposable pad palettes easiest to use because, once you have finished for the day, you just peel off the top layer and throw it away. Cleaning up after oil painting can be quite an involved process at the best of times because you need to use solvents instead of water. Anything you can do to keep things easy is worthwhile in my opinion.

Palettes for watercolour and ink

Palettes for watercolours often come attached to the box that contains the paints themselves. They are shallow, compartmentalized trays that fold out but you can also buy a separate one if you need more space. They are separated into compartments because watercolours are used so thinly that otherwise all your colours would run into each other.

Chinese ink is a similar thin watery material and is used in the same way as watercolours by diluting it with water to make thinner/lighter shades. For this reason, palettes for ink also need to be compartmentalized so that you can keep the different shades separate. You can buy flower-shaped palettes and flat, rectangular, compartmentalized tray palettes from most art shops.

RAGS

When painting it is always useful to have some old rags at hand for wiping your brushes on, either after washing them in between colours or just for dabbing off excess paint. You can use tissue or kitchen roll for thin, watery paints, but when using thicker paints it's best to use rags made of cotton or a similar material because you need the strength of the fabric. I use old dusters or scraps of old cut-up clothes or sheets.

SURFACES

The drawing or painting surface, sometimes referred to as the 'support', varies according to which medium you are using. If you are painting with oil or acrylic, you would usually use canvas or board to paint on because they are stronger. The surface most commonly used for drawing, ink or watercolours is paper. Art paper varies wildly in thickness, quality and cost.

ACETATE

Acetate can be a useful aid for painting and drawing, particularly when you want to break down an image into manageable sections during the planning stages. It is readily available from stationers in A4 and A3, and can be placed over photographs or any two-dimensional image and then drawn onto with a whiteboard pen. It is especially useful when drawing from a grid (see page 99). Using acetate in this way also works well when showing children how to break up forms into different sections that they can understand more easily.

FIXATIVE

Fixative comes in aerosol cans and you can buy it in all art shops. It is essentially a spray-on glue that is applied to finished pastel works to bind all the powdery particles together so that they are less loose and likely to blow away or rub off. You can also use fixative on charcoal drawings and even pencil drawings if you wish to protect them. Most types of fixative are invisible to the eye as long as they are sprayed on from a decent distance. They smell quite strong and should be kept away from children. Always fix in a well-ventilated area or outside if you can.

A good, cheap alternative to artists' fixative is hairspray, which will work in a similar way when sprayed onto pastels and other drawings. The only drawback is that hairspray can sometimes discolour the work over time.

Getting Started

When starting a painting, there are three main things to consider – subject, medium and style – and they will all affect what you are communicating with your artwork.

At first you might not be too worried about 'what you are communicating' – you might be feeling inspired and just want to get going. This is fine and the best way to start, but this section introduces you to the idea that whenever you make an artwork, you need to make decisions along the way. It will help to open your mind to the various possibilities available when you start out, so that you don't necessarily have to feel constricted by what you have done before, either as an adult or at school.

SUBJECT

The type of subject you choose is central to your artwork. The subject – through its nature and character, and our associations with it – will reflect some aspect of life that you are trying to convey. In still life, for example, there are objects that by their very nature look joyful and full of life, like flowers and fresh food. There are other objects that might suggest darker aspects of life or even death.

You can choose subjects that are common or unusual, traditional, modern or retro, natural or manmade, light and happy, or dark and grim. What interests you and how can your choice of subject reflect this?

MEDIUM

Most people who haven't done much drawing or painting like to start with pencil on paper. These materials are very accessible and most people have them lying around, but they can be quite unforgiving at first. So, as well as trying to get to grips with a regular pencil and paper, it's a good idea to use other materials from the outset as well, if you can, as they might help you to improve your seeing and drawing skills. Try to have an experimental approach to materials and surfaces: use charcoal, and midtone paper, or maybe a drawing pen and some coloured and white pencils. Have a look through this book and be inspired to use materials and surfaces that you might not have considered before.

Sometimes working with a new material or using a different approach can lead you into seeing and representing things in a way that is much more tactile and accessible than you thought possible with plain old pencil on paper.

STYLE

When painting a subject, you can do so in a very photorealistic way and just try to represent the subject exactly as you see it, or you might choose to be a little looser and more expressive. Style is something that you can control to an extent, but it will also depend on your skills and taste. This book will give you a better idea of how to represent your subject accurately and refine your observational skills, but there are also exercises to help you loosen up and try something altogether more playful and experimental.

Subject

Still Life

For someone just starting to paint and draw, still life is a great place to begin because it can be done at home with just a table and your choice of the wide range of household objects to put on top of it.

Still lifes can be simple, with just one or two objects in plain surroundings, or complex and busy, with many different objects of different shapes and sizes on a patterned surface with a patterned background.

Still lifes are composed generally of either natural or manmade objects or a mixture of the two. Usually the objects are inanimate, such as cut flowers and coffee pots, but not exclusively so. Henri Matisse, for example, sometimes included live goldfish in large jars, and it's not unusual to see living plants in still lifes.

There can be a tendency when working with still lifes to focus on more traditional subject matter, but if you want to add a more contemporary feel it can be worth looking for objects that reflect how we live today – things we might naturally discount when thinking about still lifes in the traditional sense.

Some examples of traditional subjects are glass bottles; fruit; crockery such as cups, plates and bowls; food; vases of flowers and plants in pots; candlesticks and traditional ornaments.

More contemporary objects might include sunglasses or headphones; technology such as laptops and smartphones; recognizably modern furniture and kitchen equipment; recent books and magazines; and gaudy or tacky ornaments.

Right: Sketchbooks of different sizes, with brilliant white and off-white paper.

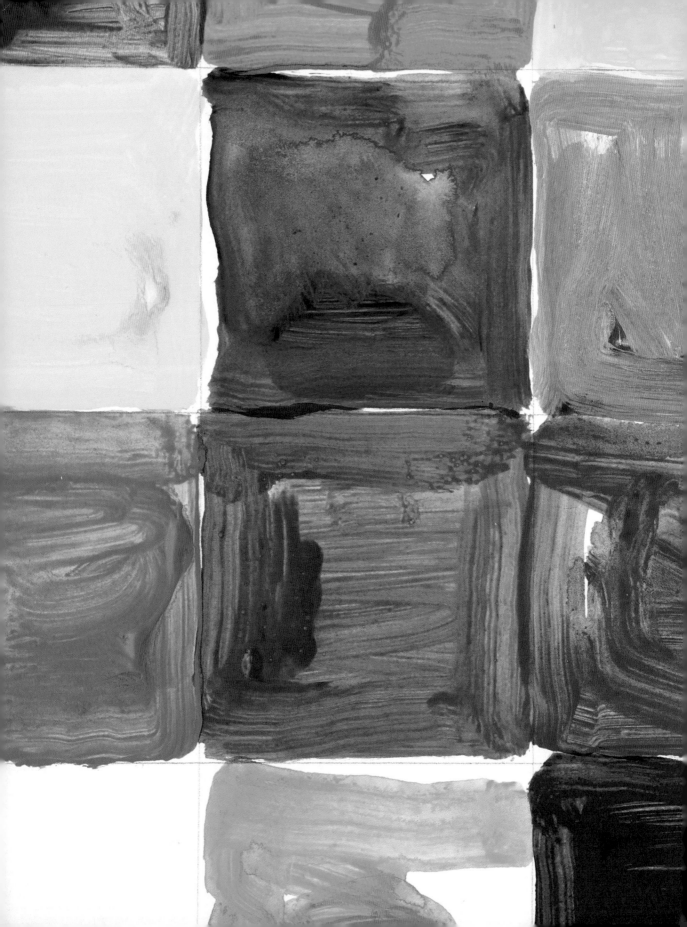

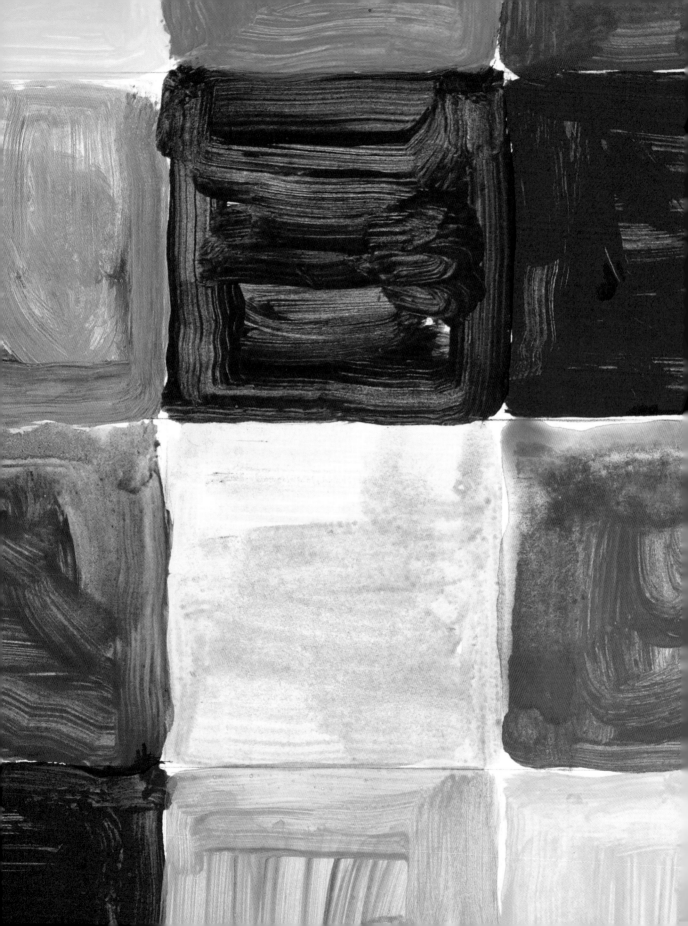

CERULEAN BLUE

ULTRAMARINE

CRIMSON

CADMIUM RED

CADMIUM YELLOW

YELLOW

WHITE

SETTING UP YOUR PALETTE

An acrylic paint palette can be made out of almost any non-absorbent surface – a plate or washed-out plastic takeaway box, for example. However, I would recommend investing in a stay-wet palette. They are not too expensive, available from most art shops and easy to clean after use. They are basically a shallow tray in which you put a layer of absorbent paper or tissue that is damp on the bottom followed by a thin non-absorbent layer similar to tracing paper. This gives you a dry surface that is cool to the touch and helps keep the paint from drying too quickly on the palette. A stay-wet palette really helps, especially if you are painting outside or in hot places where small amounts of mixed colour will otherwise dry very quickly and make continuity difficult.

I recommend starting with a fairly limited palette in terms of the range of colours so that you get to know the difference between the individual primary pigments.

Start with one blob of each colour along the side of the palette. Follow the colours illustrated (opposite page) and always try to place the colours in the same order if you can – this will help you become quicker at mixing as you will soon know where the different colours come on the palette.

You need a pot of water for washing your brushes (it's best to use something throwaway but washable like half a large plastic water bottle as opposed to something more precious).

You also need some kitchen roll or rags for removing excess water from the brushes after washing.

BRUSHES

The size and shape of the brush you use will affect the type and look of the mark that you make with each individual brushstroke. When getting started using acrylic paint I would suggest investing in at least four brushes: small, medium and large round-ended brushes plus a small pointed brush for detail.

BLENDING ACRYLICS

Acrylic paints dry quickly so you will need to work fast. It might take a couple of layers and some practice if you are after a very smooth look.

It can help to create dark, medium and light versions of your blended colours in advance and in large enough quantities so that they are not going to dry too quickly while you are applying them.

Practise using a clean, damp brush to blend two colours once they have been applied to the surface. It is unusual to mix colours on the surface you are painting on as the vast majority of colour mixing happens on the palette before it touches the surface. The exception is when blending to a smooth gradient from one colour to the next on the surface of the painting itself.

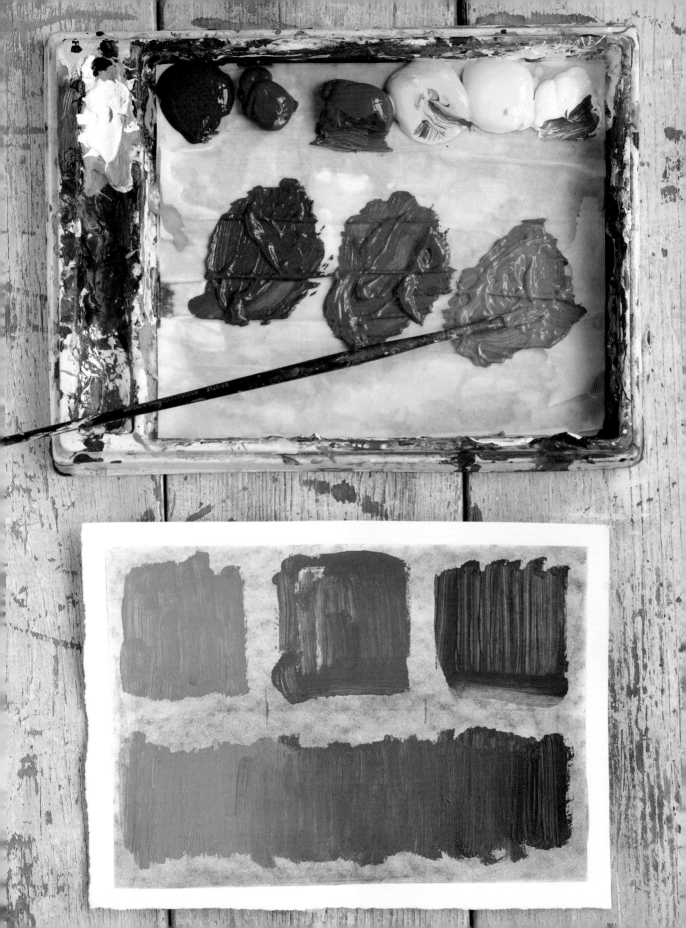

QUICK EXERCISE: BLENDING ACRYLICS

You will need:

- ► a rectangle of white paper suitable for acrylic painting
- ► stay-wet acrylic palette set up as pictured
- ► brush
- ► ruler
- ► pencil
- ► charcoal, masking tape and a board (optional)

1 Divide the paper in half lengthways and mark out with pencil three equal sections on each half.

2 Tape the paper down to a board using masking tape along the edges.

3 Cover the paper in charcoal and rub off the excess using a cloth to achieve a mid-grey background.

4 On the palette, mix a dark, a medium and a light version of a colour – we chose an earthy red.

5 Fill the three sections on the top row with each version of the colour and do the same with the squares on the bottom row.

6 Mix the dark and medium versions of the colour in the palette together and layer over the boundary between the dark and medium squares on the bottom row.

7 Then mix the medium and the light versions of the colour together in the palette and use that to blend the border between the medium and light sections on the bottom row.

8 Use a clean, wet brush to blend any areas where the gradation from dark to light is not smooth. Try and work quickly as the more the paint dries the harder it will be to blend smoothly.

Left: A palette with large amounts of three shades of the same colour – dark, medium and light. Below shows how the colours look on paper, both separately and when blended smoothly.

Oils

Oil paints are what many people aspire to use when they first think of painting. There is a romance surrounding them, and for many people just the smell can conjure up images of sun-bathed Parisian studios and artists labouring away in decadence and dedication – living the creative dream. Oil paints were the medium of choice for many of the most famous painters and they have been used to create masterpieces for centuries, which is probably why so many people think of oil paints as *the* medium for serious painting.

Oils can be very slow to dry, sometimes taking months for thick layers to fully dry. This tends to dictate a slower pace of work than with faster-drying mediums such as acrylics. As a result, oils may not suit everyone.

AT A GLANCE: OIL PAINTS

- ► Versatile, as they can be used thickly or thinly.
- ► Not usually soluble in water (though water-soluble oil paints are now available); they are thinned with turpentine, linseed oil, white spirit or a combination of these.
- ► Easy to blend and can be reworked and corrected fairly easily.
- ► Slow drying.
- ► Typically used on oil painting paper and stretched canvas though you can also try using them on board or wooden panels.

THINGS TO CONSIDER ...

- ► Work somewhere that is well ventilated and always have a window open.
- ► Layering – thin layers on the bottom (underpainting), thicker layers and detail on top. These thin layers will dry fastest.

- ► Brushes – the best brushes for oil painting are hard-bristled; use fine brushes for detail.
- ► Which surface to use – usually primed canvas but you can also buy pads of special oil painting paper, which is quite textured (this can be a cheaper alternative while you are learning).
- ► Palette – work with a limited palette at first to help you get to grips with the basics of colour mixing.
- ► Set-up – you will need a sealable old jam jar or a hermetically sealed jar (available from most art shops) to let used medium (see page 60) settle so that you can separate off the clean solvent for reuse and store the waste safely; you will also need rags or kitchen roll for wiping excess medium and paint from cleaned and dirty brushes.

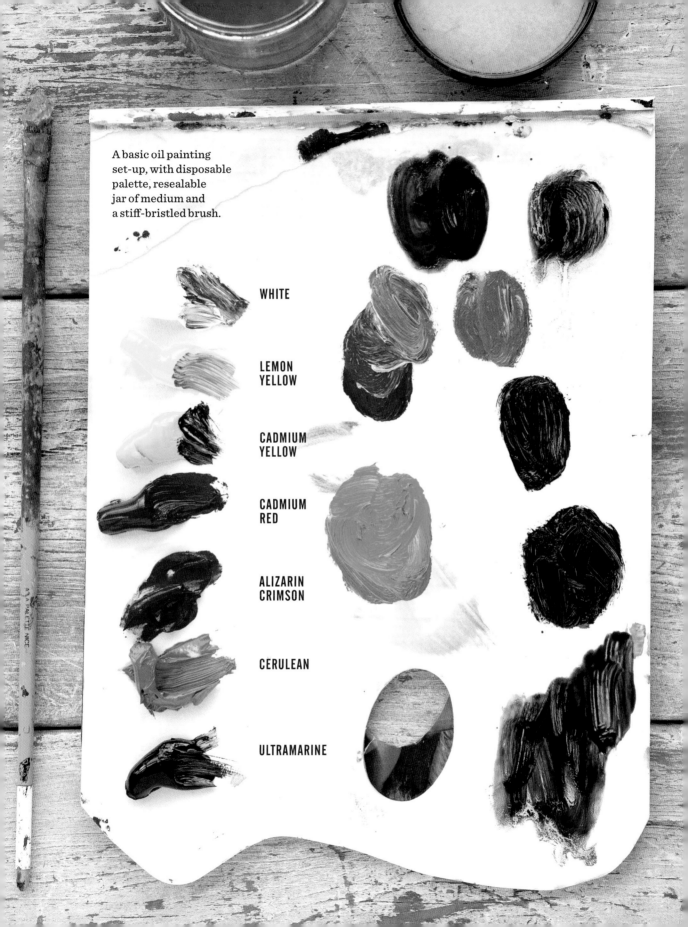

A basic oil painting set-up, with disposable palette, resealable jar of medium and a stiff-bristled brush.

WHITE

LEMON YELLOW

CADMIUM YELLOW

CADMIUM RED

ALIZARIN CRIMSON

CERULEAN

ULTRAMARINE

OIL PAINTING MEDIUMS

Mediums such as turpentine or linseed oil are mixed with oil paint to thin it and to either increase or decrease the drying time. Oil-based mediums will tend to increase the drying time while solvent-based mediums, usually turpentine, will speed up the process.

If you are a beginner, start with a general purpose low-odour medium. Most pre-mixed mediums will be a mixture of oil and solvent. These are readily available and make for a more pleasant and safer environment than turpentine, which has a strong chemical smell. When you are just getting started with oil paint, don't worry too much about drying times – the best way to learn is just to have a go. If you really take to it, then experiment with adding different mediums to control the drying time of the paint.

Drying time depends on the kind of medium you use, how thickly you apply the paint, and the ventilation and temperature of the area in which you paint. You will soon get a feel for how long you can leave the painting before the paints dry and become unblendable.

Mediums need to be disposed of responsibly – not down the sink or into the bin as they are toxic. Seal solvents like white spirit and turpentine in containers; your local recycling service may take them away or you may need to take them to a hazardous waste disposal facility.

It is possible to use fairly small amounts of solvents by leaving them to settle after use and then pouring off the clean solvent for reuse. The remaining oil paint residue and used medium needs to be disposed of responsibly in the same way as the solvent itself.

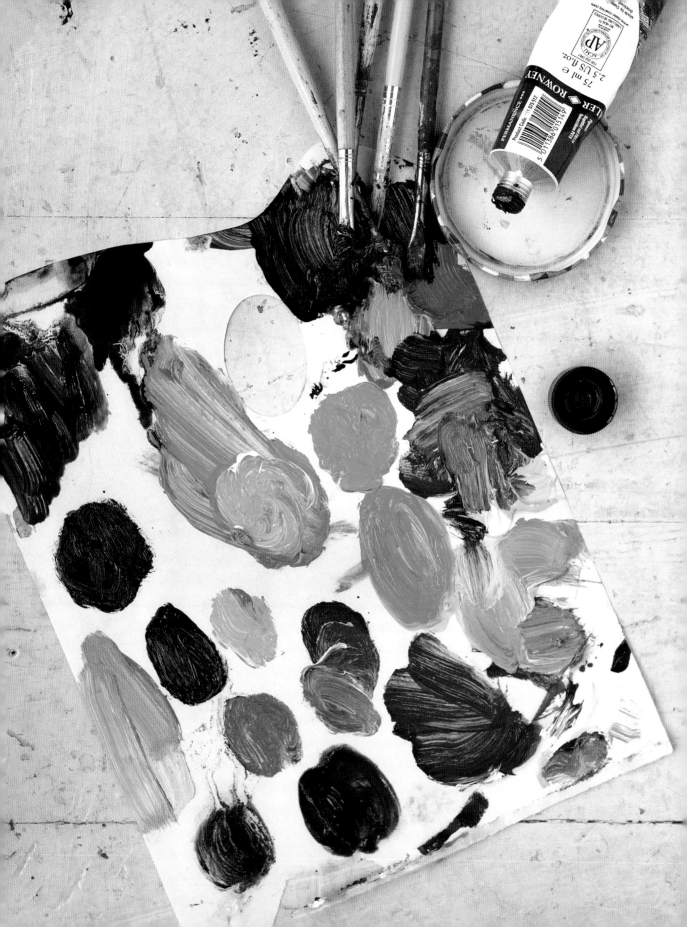

QUICK EXERCISE: DRYING TIMES

You will need:

- ▶ appropriate surface (oil painting paper or a small canvas)
- ▶ pencil
- ▶ ruler
- ▶ palette
- ▶ a stiff-bristled brush
- ▶ low-odour citrus medium
- ▶ oil paint colour of your choice

1 Divide the surface into four equal sections using a pencil to mark the sections out.

2 Squeeze some oil paint onto a palette and pour some oil painting medium, such as a low-odour citrus medium, into a closable jar.

3 In the first square apply undiluted oil paint. Paint the remaining sections with increasing amounts of medium added to the paint.

4 Set aside once you have finished the four different sections. Return in about eight hours to test if any of the sections are dry by touching them lightly with your finger.

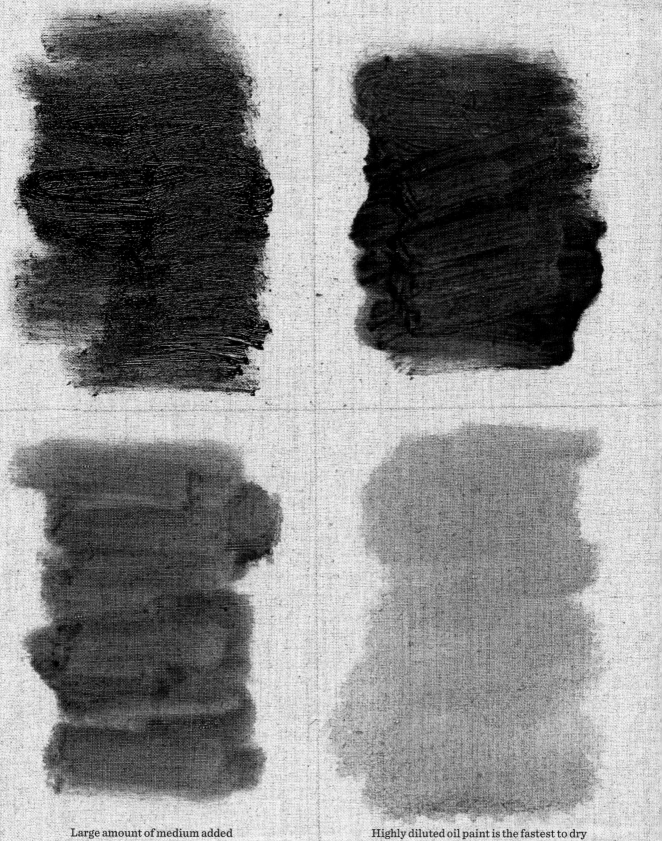

Undiluted oil paint is the slowest to dry

Smalll amount of medium added

Large amount of medium added

Highly diluted oil paint is the fastest to dry

Watercolours

Watercolours are hugely popular but they have a reputation for being fairly difficult. This is mainly because of the translucency of the paint, which means that mistakes can be difficult to cover up. But don't be put off.

Painting with watercolours requires a slightly different way of thinking from painting with thicker, more opaque paints. In other types of painting you are usually looking for the areas that need to be filled, and you can add areas of light later by using white paint. For watercolour painting, you need to do the opposite: areas of light are often just left blank, so you have to decide where *not* to paint. You need to know where the light areas of the painting are going to be at the beginning, so you can paint around them to define their edges, and not accidentally paint over them with a medium or dark tone.

When working with watercolours, it is fairly unusual to use much white paint. Colours are simply lightened by adding more water to make them thinner so that more of the white surface of the paper shows through.

It is important that you are careful when adding colours – and especially medium or dark tones – as mistakes will be difficult to correct. Although it is unusual to use much white when watercolour painting, it can help to have a tube at hand when you are just starting out so that if you do cover over light areas by mistake, you can add white on top to correct them as best you can. However, even if you add white paint on top, the colour beneath may still show through.

AT A GLANCE: WATERCOLOURS

▶ Water-soluble and easy to clean up.
▶ Best used on white watercolour paper.
▶ Quick drying.
▶ Colours are translucent in nature; they need to be applied thickly in order to look rich and deep.
▶ Can be difficult to correct mistakes.

THINGS TO CONSIDER ...

▶ Soft-bristled brushes work best for watery paint; you will need at least one large, one small and one medium.
▶ When covering large areas with a very liquid wash, it is easier to work on a flat surface, especially at first, as opposed to upright on an easel; very thin paint drips a lot and can be a problem when working upright.
▶ Layering (see page 68).
▶ Decide at the beginning which areas you want to keep free of paint.
▶ Wetting the paper before blending.

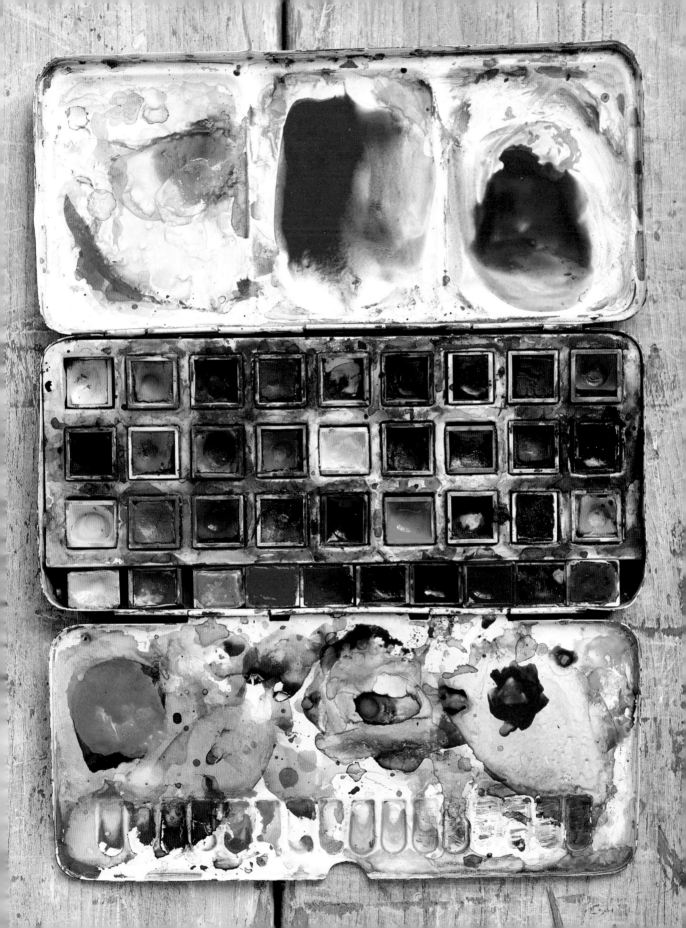

PALETTE

Try using a box of block watercolours. They also come in liquid form in tubes, but you are likely to find the folding boxes with incorporated palettes much easier to use. Most boxes have some mixing space included within their design, and the palettes or mixing areas are usually shallow and compartmentalized to keep the liquid paints from running into each other.

LAYERING

Watercolours are translucent, so you will see dark areas even if you have painted over them with light colours. This means that you need to plan watercolours more carefully, and make initial layers and marks in fairly light thin tones, as you only add darks when you are really sure of where to put them.

BLENDING

Watercolours are fairly quick drying so they can be difficult to blend smoothly. Adding water with a sponge or brush to the area that you want to blend before adding the paint can help to get a smooth gradation from light to dark or from one colour to the next. Wetting the paper will help the colours run into each other more evenly and spread across the area smoothly without drying too quickly. It can also be handy to wet the whole surface of the paper if, for instance, you want to achieve a smooth, flat wash colour across the whole painting as a base.

MASKING FLUID

You can use masking fluid to cover areas that need to be kept light. This is usually applied before any other painting is done. Masking fluid is a liquid rubber substance that is painted onto the surface of the paper and left to dry; it solidifies and forms a watertight layer over the surface of the paper. Normal painting is then resumed and when you are ready you can peel off the masking fluid and reveal the perfectly preserved white areas beneath.

SURFACE

Watercolours call for white paper and not much else. You can buy pads of watercolour paper in art shops. The sheets are usually thick and fairly textured; thinner paper ruckles too much when using such watery paint.

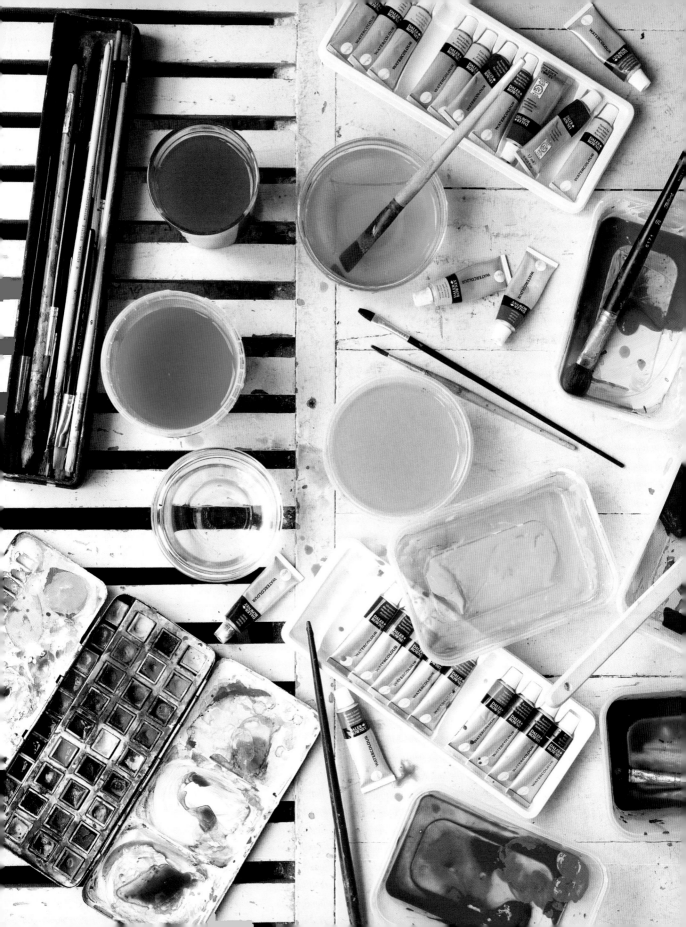

QUICK EXERCISE: WORKING ON WET AND DRY PAPER

You will need:

- ► two sheets of watercolour paper
- ► a small sponge or cloth
- ► watercolours
- ► a pot of water
- ► a medium to large brush
- ► masking tape and board

1 If you'd like to leave a border of white paper around the edges of your two pieces of paper then tape them all the way around the edge onto a stiff board with masking tape.

2 Wet one of the bits of paper using the sponge or cloth so that it is completely damp but not so wet that water is puddling on the surface. Leave the other sheet dry.

3 Using four different colours and the medium-sized brush, paint stripes of colour across both sheets in the same order.

4 Notice how the colours on the dampened sheet bleed and blend into each other whereas the stripes on the dry sheet stay more separate.

Right: The sheet on the top was dampened before the colours were added. The one on the bottom was not. Colours blend more easily when added to wet paper.

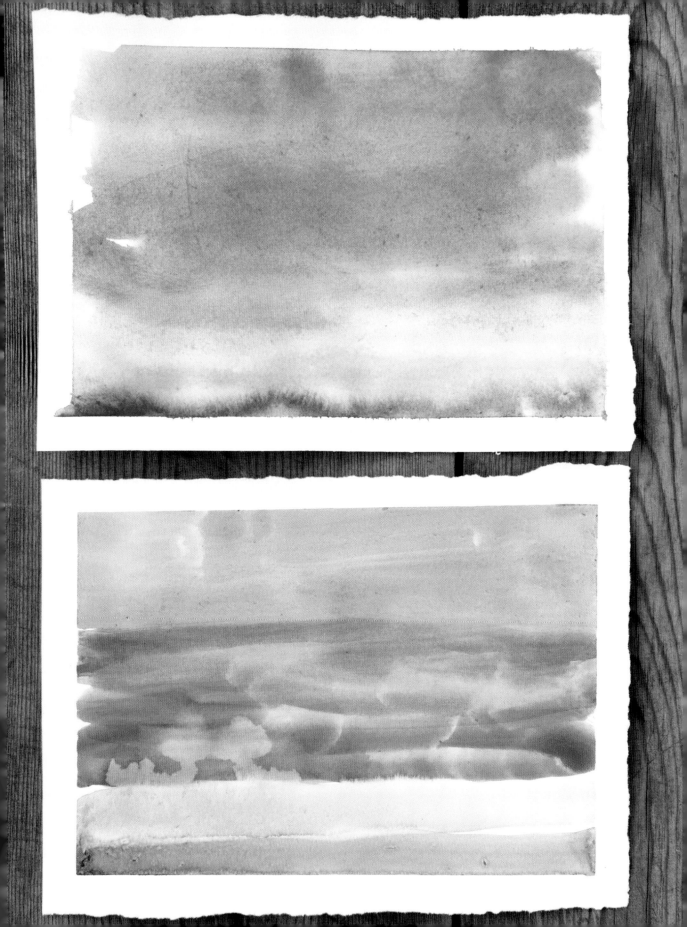

Inks

Ink is a beautiful material to work with and not difficult or complicated. Essentially very densely coloured liquid, it can be diluted with water for different intensities of tone. When used undiluted and painted onto paper with a brush it gives pure, opaque black marks. When it is diluted with water it becomes transparent and grey, the lightness depending on how much water you add. It can be used as a mark-making material or for staining paper to various tones to use in collage.

Some inks are insoluble after drying, and usually referred to as permanent. Drawings or paintings using non-permanent ink can be manipulated after drying by adding water.

Ink is usually used on its own to make monochrome tonal pictures or line drawings. It's great for creating atmospheric night-time scenes. The range of tones that you can make lend finished pieces a kind of photographic intensity.

AT A GLANCE: INK

▶ A dark black liquid.
▶ Coloured inks are also available.
▶ Very runny, so best to work flat on a table.
▶ Can be used to stain paper for collage.
▶ Creates a wide range of tones from very light grey when highly diluted to jet black when used pure.
▶ Only really works on paper and not canvas.
▶ Can be difficult to correct mistakes.
▶ Use soft-bristled brushes.

THINGS TO CONSIDER ...

▶ Ink acts in a similar way to watercolour in that it can be difficult to correct mistakes as it is not possible to cover darks with lights (unless working in collage). This is because lights are just diluted versions of the pure black ink, so are translucent.
▶ Mistakes are difficult to correct so it helps to plan the picture you intend to make and be sure which areas you intend to leave light, just as you would with watercolour. You can use masking fluid to help you with this (see page 68).
▶ Use a shallow, compartmentalized palette for keeping different tones separate.
▶ When preparing paper consider taping all around the edge to leave a white border when the tape is removed.
▶ As with watercolour, dampening the surface of the paper before applying ink allows the ink to spread and blend more easily.

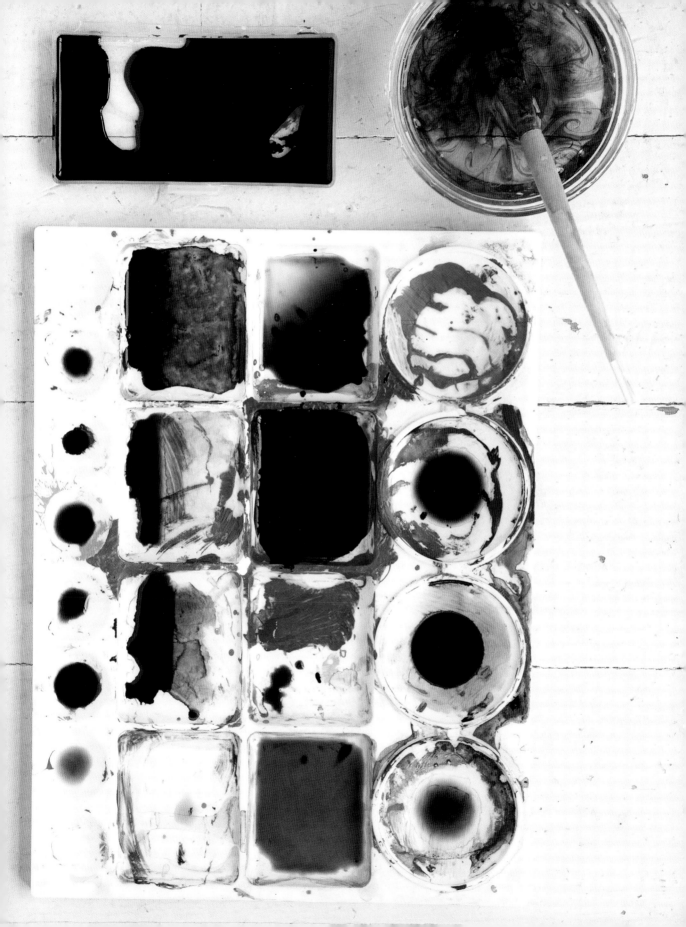

QUICK EXERCISE: EXPERIMENTING WITH MASKING FLUID

You will need:

- a sheet of watercolour paper
- black ink such as Chinese ink
- water for diluting the ink
- masking fluid and a pot to decant it into
- an old brush that you don't mind ruining
- a medium-sized round-ended watercolour brush
- masking tape
- stiff board

1 Divide the paper into four sections by folding.

2 Fix the sheet of paper onto the board with masking tape all around the edge.

3 Decant some of the masking fluid into a shallow pot.

4 Using the old brush, paint masking fluid in a simple pattern onto each of the four sections of paper.

5 Set aside and leave to dry. Depending on the thickness of the masking fluid, this could take around an hour.

6 When the masking fluid is dry, paint the different sections with different dilutions of ink using the watercolour brush – some dark and some light. Set aside to dry.

7 When the ink is dry, carefully peel off the masking fluid to reveal the white paper underneath. I find that the best way to do this is to rub with the pad of your finger instead of using your nails.

Right: Simple patterns painted in masking fluid, covered with varying dilutions of ink and then peeled off when dry.

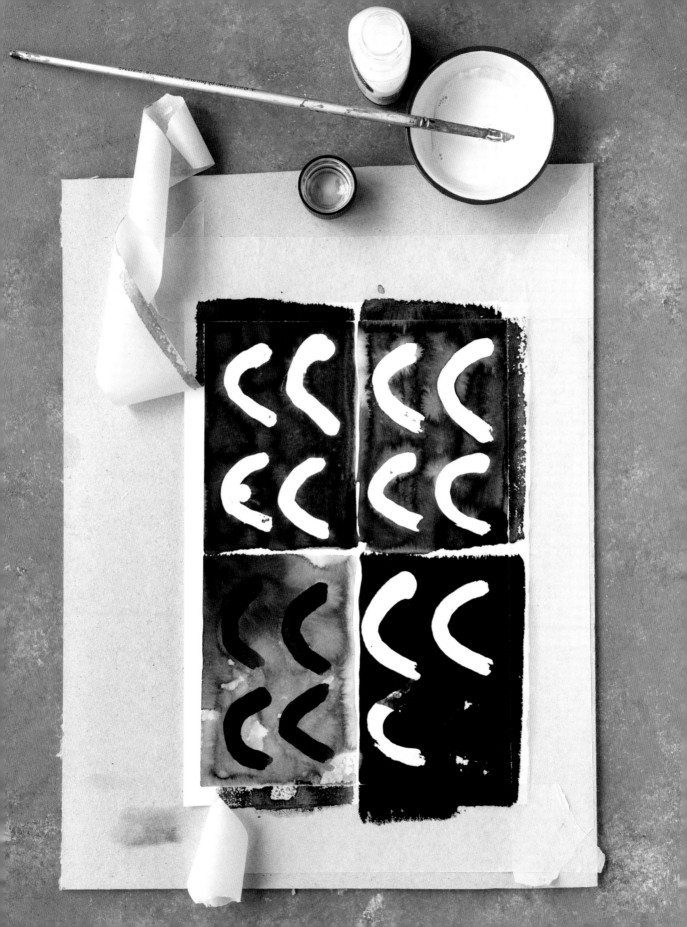

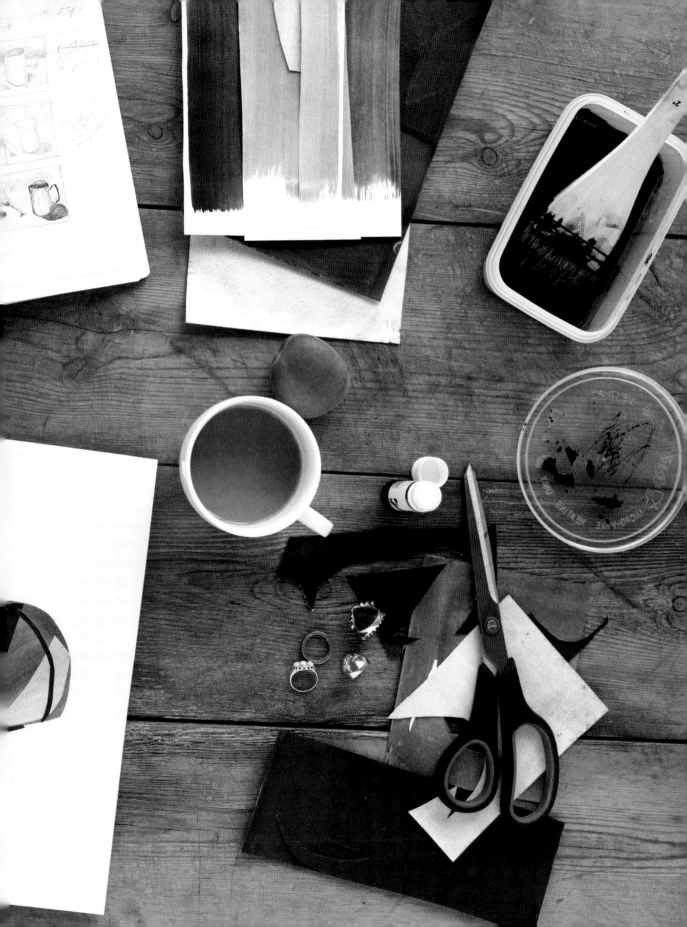

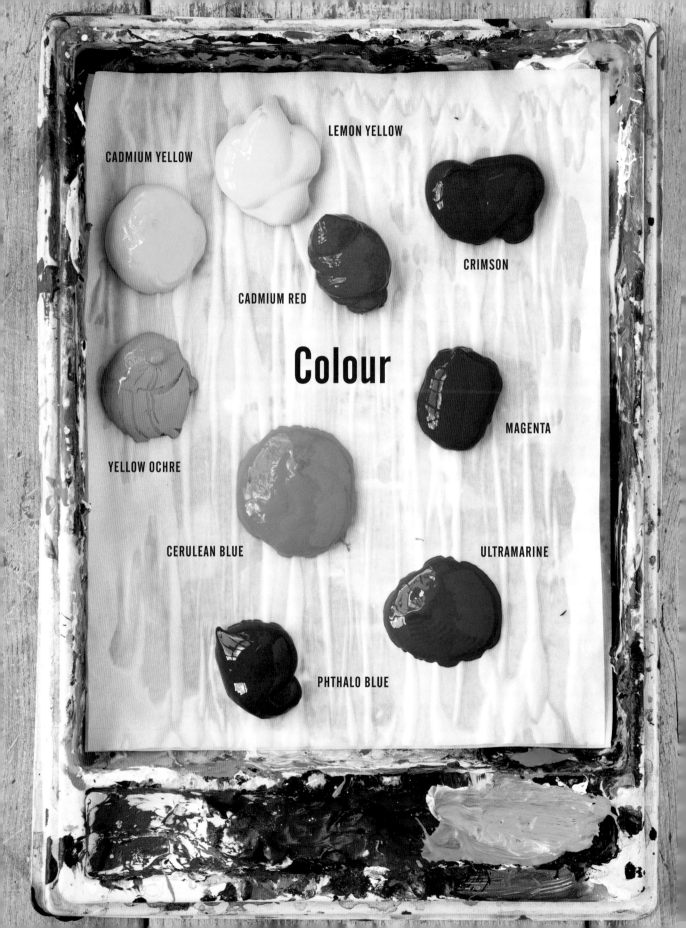

CADMIUM YELLOW

LEMON YELLOW

CRIMSON

CADMIUM RED

Colour

YELLOW OCHRE

MAGENTA

CERULEAN BLUE

ULTRAMARINE

PHTHALO BLUE

As a rule, the principles of colour and how different colours mix are the same across all media. Whether you are working in acrylic paint or pastel, if you mix lemon yellow with cerulean blue, you will get a similar green colour in both mediums.

To understand how colour works, a good knowledge of the common pigments of each primary colour is essential. From there, you can mix those primary pigments in different combinations to create a range of secondary colours.

PRIMARY COLOURS

The primary colours are **red**, **yellow** and **blue.**

Within red, common pigments include crimson, cadmium red and magenta.

Within blue, common pigments include cerulean blue, ultramarine and phthalo blue.

Within yellow, common pigments include lemon yellow, cadmium yellow and yellow ochre.

There are many more pigments than these, but it's good initially to get to grip with these nine.

SECONDARY COLOURS

Secondary colours come from mixing two primary colours together. The key is that the secondary colours you make from mixing different primary pigments are markedly different. The green that results from mixing cadmium yellow and ultramarine will be a dirty shade, compared with the bright emerald-type green achieved when mixing lemon yellow and cerulean blue. By working with primary colours at first and understanding how to make various versions of secondary colours, rather than by using readymade secondary colours, you will have much more control and a better understanding of colour in the long run. This is especially true for acrylic and oil painting, but slightly less so for pastels and watercolours.

COMPLEMENTARY COLOURS

When you first squeeze new paint from a tube, the colours are pure and untainted, or clean. I would describe them as bright even if they are relatively dark colours like ultramarine blue. Complementary colours 'neutralize' each other – this means that if you add red, yellow and blue together, you will always get brown or black, depending on the primary pigments and the quantities used. Rather than fully neutralizing the colours with equal amounts, most often you will use a lesser amount of a complementary colour to reduce the brightness of a pure colour.

Purple is complementary to yellow.

Orange is complementary to blue.

Red is complementary to green.

MAKING BROWNS AND BLACKS

To achieve brown, I would suggest making a green first (blue + yellow) and then adding red to it. Making black by mixing all three primary colours can take a bit of practice, but it is worth it. To do this you can make a dark purple (dark red + dark blue) and then add lemon yellow to it in small amounts, mixing well. Of course, you can just buy blacks and browns, but a hand-mixed black is subtler than your average readymade black and so is less likely to unbalance a painting.

TRANSLUCENCY AND OPACITY

The colour that you see on the finished work will also depend on the thickness of the material that you are using, and the colour of the surface that you are working on. If you thin the paint down to make it more translucent, you will see more of the surface colour coming through. This will have a lightening effect on the colour if the background surface is light or white, and a darkening effect if the background colour is dark. You can do the same with pastels by using a thinner or thicker covering.

The illustrations in this section all feature acrylic paint for the sake of consistency but mixing the same colours in any other medium will result in the same secondary and tertiary colour.

Mixing ultramarine, crimson and a small amount of lemon yellow will make black.

Mixing cerulean blue, cadmium yellow and cadmium red will create brown.

DARKENING AND LIGHTENING

In order to get a lighter/paler version of a primary colour, white is added, depending on the medium – in the case of watercolours, water is added to make the colour more transparent.

Just adding white to primary colours and some secondary colours will often give you colours that are still bright and clean, but lighter.

If you want to dull down or 'dirty' the brightness of a pure colour you can add black, brown or a dash of a neutralizing colour.

For example, lemon yellow is a bright, clean yellow when you first squeeze it from the tube, but if you want to create a more pastel yellow, you can take the brightness out by adding a bit of purple (made by mixing blue and red) or black. Then you can lighten it again by adding white. If you just added white without adding the purple or black, it might be lighter but it would still be clean and bright (see illustration opposite).

Adding blues and reds will usually make your colour darker. By contrast, yellow is a lightening colour. For example, any green will be darkened by the addition of red or blue but will be lightened by the addition of yellow. The same is true for orange: add blue or red and you will darken it, and add yellow and you will lighten it.

You might think that you could just lighten green or orange with white rather than yellow, but often the resultant colour can seem duller than you want.

All reds can be darkened by the addition of blue, and all blues can be darkened by the addition of reds and oranges.

SKIN COLOUR

Imagine that you are trying to make a variety of 'white' skin colours. You might start by making some pastel orange and some pink, but you might find that these on their own look too bright, clean and unrealistic. They need to be tempered down and neutralized a little.

If you add a little blue to the pastel orange, and a little green to the pink, you will get colours that are a little less bright and a little more neutral. The results are more realistic skin tones. It can take experimentation to get colours just right, but it is worth the time and effort. You can always test the colours on scrap paper before adding them to your piece.

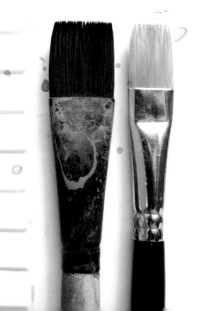

Right: This palette shows the various yellows you can make by adding black and white in varying amounts to lemon yellow. Different greys are also shown, created by adding white to homemade black. If your grey is too purple-coloured in tone, then adding a touch of lemon yellow can help to neutralize it.

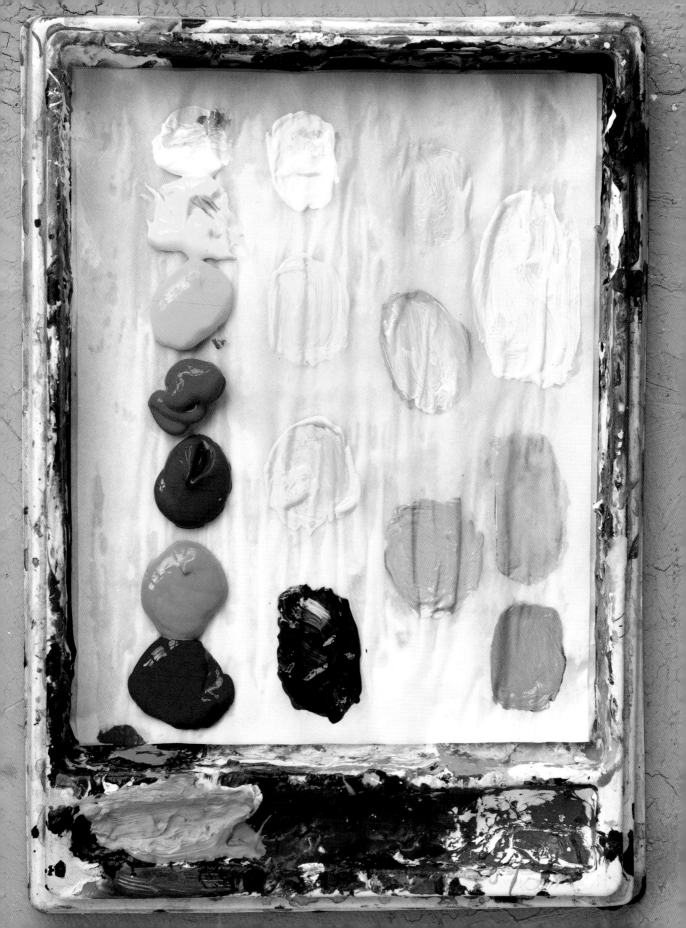

Style and Technique

People tend to think that drawing is one of those things entirely dependent on innate talent – either you have it or you don't. But, armed with a few basic principles, anyone can do it. You'll be amazed at how quickly you'll be able to get to grips with the subtleties of line and tone.

Drawing Techniques

The principles of seeing light and dark are the same in drawing and painting. Once you've learned about line and tone in drawing you can then apply these principles to painting.

It's important to remember, though, that there is no right or wrong when it comes to drawing technique. In this section I will explain the thought processes involved in calculating spatial relationships, which should be helpful to you, but there are no hard and fast rules.

I like to break drawing down into **line** and **tone**. We'll start with a section on how to see and put down on paper the correct lines, followed by a section on how to see and capture tone. I find it's best to get all your lines in first and then start putting tone in later.

Remember, making mistakes is key to learning to draw so try not to worry. Often, putting the wrong line in can help you work out what is the right line. Drawing is a one-step-forward-two-steps-back activity – perfection from the start, as with most things, is impossible.

Choose simple subjects at first and keep going because practice is key to drawing. Eventually the thought processes described in the following sections will become second nature and you'll be able to draw almost anything.

Line

Drawing is the process by which you convert a three-dimensional scene or object into a two-dimensional image on a page. In order to do that, you need to be able to understand and see that scene or object in two dimensions as much as possible.

A simple physical trick for helping you to see in two dimensions is to close one eye. This will reduce depth perception, making things look flatter.

Lines, then, become edges, and when you are drawing it is the edges of two-dimensional forms you are looking for.

This is not to say that whenever you are drawing you will always sit there with only one eye open. But when you draw you can close one eye occasionally to help you to see the edge of an object in two dimensions.

For any particular line, be it the edge of the petal of a lily, the top of a human arm or the outline of mountain tops across the sky, you should always try to determine what that line is really doing. For example, is it generally vertical – i.e. is the top point of it directly or nearly above the bottom point of it, even if it wiggles about a bit in between? – or is it generally horizontal or diagonal? Is it a curve or a straight line? Does the line have any lumps and bumps and if so how far along it do these come? Is it broken up into different sections, all of which are at different angles?

Asking questions like these will help you learn to see that object in a different way – and good 'seeing' is critical to good drawing. Try to work out where the line

starts, how high and how far across the page it needs to be, and how it relates to the other lines that you have already drawn. These are the thought processes and mental habits that all artists use to get the correct line.

VERTICAL LINES, HORIZONTAL LINES AND DIAGONAL RELATIONSHIPS

In order to draw you need to see where one thing is in relation to another. One of the simplest and most effective things you can do is to use imaginary vertical and horizontal lines to help you calculate spatial relationships between different points. I often describe these imaginary lines as thought lines. You use them so that you can check what is directly above or below and to the left or right of something you have just drawn. It is the action of looking and thinking that is crucial to making accurate drawings, not the lines themselves – drawing vertical and horizontal lines on the page itself can be confusing. Try to keep your drawing free of any lines that do not actually exist in real life.

Vertical lines (or plumb lines) help you determine whether a given point is to the left or the right of another or whether a point is directly above or below another on the same vertical line. Artists often hold their pencil up in-between their eye and the object/scene in order to help them visualize these vertical lines. It is often

VERTICAL

▶ **Line 1** helps us to see that the model's front knee is just to the right of the edge of her front elbow, and shows that the midde of her ankle on the same leg is vertically below the edge of the elbow line.

▶ **Line 2** shows that the front of her back ankle is directly below her cheek.

▶ **Line 3** shows that her back elbow is the widest point on that side as it goes straight down to the ground without passing through any other part of her on the way down.

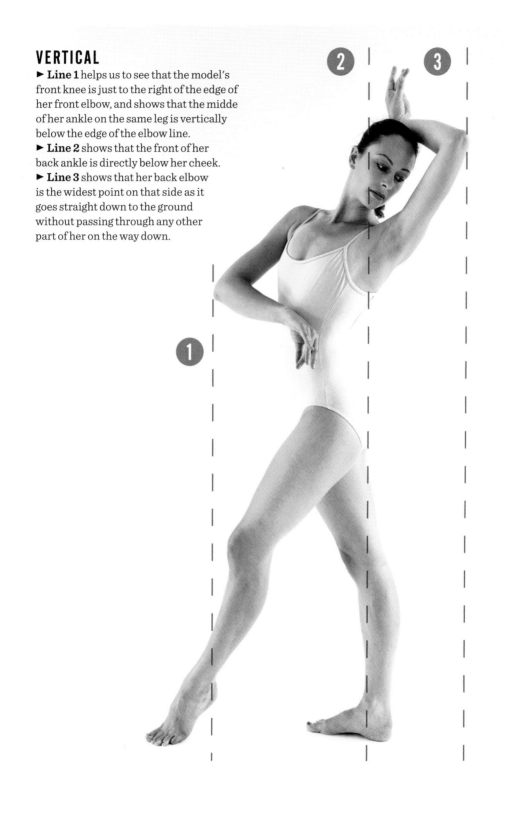

HORIZONTAL

▶ **Line 1** Imagining a horizontal line going along the axis (middle) of the arm on the left helps us to see that the other arms sits just above this line.

▶ **Line 2** Taking a horizontal line through the left knee helps us to see that the right knee is lower down than it.

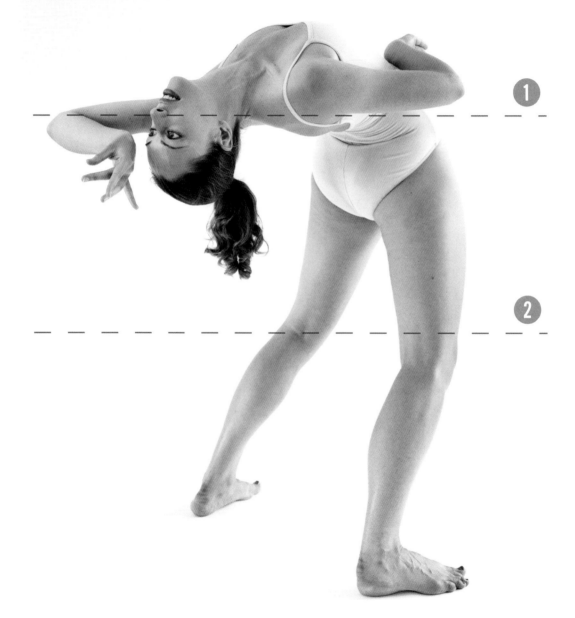

useful to work out where the widest point of an object is when you are drawing it. Use your imaginary lines to do this by checking that a vertical line going down from the point that we think is the widest goes straight down and does not pass through any other part of that object on the way.

Horizontal lines work in a similar way – you can imagine a horizontal line shooting out from any particular point on an object and compare it with other points near that line. Are the other points on the same horizontal line, or are they higher or lower? If higher or lower, by how much? You can then begin to plot where points are in relation to each other on the page.

Although it can be helpful to plot points on the page, you can't rely too much on this in advance. Often you need to get the wrong line down on the paper first in order to notice that it is not right and then correct it. If you spend half an hour painstakingly plotting lots of points onto a page before you actually draw any lines, you will work far more slowly than if you plot where to take a line to and then get that line in before you plot the next point.

You can also hold up your pencil to help see the right **diagonal relationships** between any two points. (All points are linked diagonally unless they are on the same vertical line or the same horizontal line.) Then bring the pencil down (maintaining its angle) to your drawing and compare the diagonal relationship you have between the same two points in the drawing.

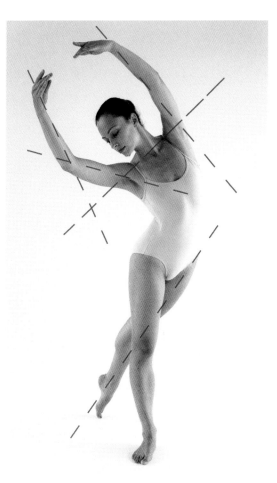

DIAGONAL

The diagonal dotted lines show how you might hold up your pencil to what you are drawing to help you see the general angle of a limb or a section of a limb or the diagonal relationship between two things that you might expect to be on the same level. For example, the diagonal relationship between her two shoulders. One is much higher up than the other.

Diagonal relationships are particularly useful for measuring the axis of limbs when drawing the human figure. For example, if you were trying to draw the dancer above it would be helpful to imagine diagonal lines going down the centre of each of her limbs. To help you do

this, hold your pencil up between you and the figure and align it with the diagonal that you are trying to determine, then holding the pencil steady to maintain it's angle, you can bring it down to the page you are drawing on to help you physically see the angle that limbs should be on the page. It can take a little practice to get the knack of holding the pencil steady while transferring it, but as long as you are holding the pencil from on top and not from underneath, you should be able to get it down to the page without changing the angle. Keep trying, because this is a skill worth having.

Spotting diagonal relationships is particularly important as your brain tends to tell you that things like shoulders, hips and knees are on the same level, when in reality they are not. We assume that the human body is symmetrical around a centre line, so may forget to check if, say, both shoulders of the figure that you are drawing are at the same level. This is where mistakes happen. Get into the habit of thinking about and checking these spatial relationships, as it will improve your drawing.

A NOTE ABOUT PERSPECTIVE

I tend to avoid using the word perspective when teaching because it sometimes confuses people. I find that encouraging people to get into the habit of using their pencil to help them physically discern the correct angle of all diagonal lines is much more effective than talking to them about vanishing points and disappearing parallel lines. You don't need to be able to understand the theory of perspective to draw a building – you just need to be able to correctly see the angle of diagonal lines in relation to vertical lines.

NEGATIVE SPACE

Negative space is simply the empty space around something, or between things. It's a concept that should help you see the wood for the trees in terms of shapes and lines in space. For instance, looking at the figure in the photo on the right there is negative space between each of her arms and her body, between her two legs and, indeed, all around her. Looking at the negative spaces as shapes in themselves and drawing them is often easier than drawing the actual limbs themselves.

Seeing negative spaces as forms themselves is useful for two reasons.

First, you make fewer assumptions about negative spaces than you do about positive forms, so it's easier to see them critically. Negative space is flat, making it easy for us to understand it and see its outlines accurately.

Second, negative space gives you the whole picture: if you were drawing a person standing up with their feet slightly apart so they have a gap between their legs, as in the photo on the right, it is the *gap* that provides the information about how far the legs are apart, whether or not one knee is higher than the other and if one leg is more angled than the other. It would be almost impossible to draw the legs correctly in relation to each other without looking at and understanding the shape of negative space between them.

NEGATIVE SPACE

Looking at negative spaces can help us to see things in two dimensions by allowing us to see the outline of shapes that may be coming towards us confusingly. For example, in this image her bent knee is coming towards us slightly, making one leg look shorter than the other. This is called foreshortening. Looking at and drawing around the negative space between the legs helps to overcome the challenge of drawing foreshortened limbs.

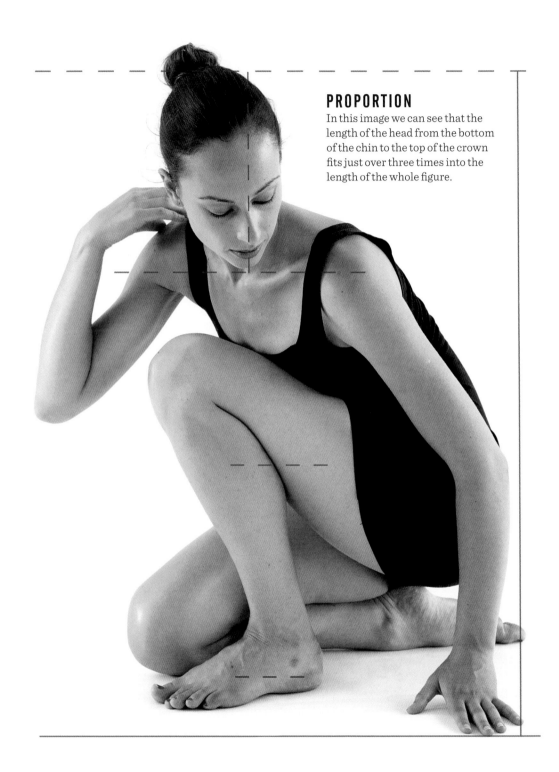

PROPORTION

In this image we can see that the length of the head from the bottom of the chin to the top of the crown fits just over three times into the length of the whole figure.

PROPORTION AND MEASURING

Proportion measures how one distance relates to another. It is necessary when you are trying to work out how long to make one line in relation to another line, and also when assessing the size of one part of an object in relation to another part or in relation to the whole.

Imagine you are drawing a stemmed glass, for example. It would be a good idea to think about how the height of the goblet part of the glass relates to the height of the stem. Is the stem longer or shorter than the goblet or are they about the same size? It's also useful to think about the width of the widest part of the goblet compared with the base of the glass. These are both proportion calculations.

Similarly, if you were drawing the crouching figure on the left, it would be useful to discern how the height of the head relates to the length of the figure from top to bottom. We can measure this by using our fingers or by holding up a pencil in front of us and measuring the distances between the end of the pencil and our thumb. The point is to see how many times the smaller distance fits into the bigger distance:

1 Frame the head between your forefinger and thumb.
2 Keeping the frame in place, move your hand down so the top is just below the head.
3 Count how many times the frame (or the height of the head) fits into the whole.

VERTICAL MIDDLE

To find the vertical middle, look at the subject as a whole and estimate the halfway point between the bottom and the top. Measure the distance by framing the bottom half with your thumb and forefinger and then move your hand up, so your thumb is where your finger was. Your forefinger should now be exactly at the top of the subject. If it's not, then you have wrongly judged the vertical middle and will need to check it again.

Proportion is also used when comparing line lengths. Every time you draw a line, you can compare each aspect of it to the line before and think, 'Does it need to be shorter, longer, more angled, straighter or more curved?'

Measuring can seem boring and mathematical, while drawing is supposed to be a creative, expressive pursuit. However, even if don't want to physically measure, you should always think about how distances relate to each other as you work.

SUBTLETY OF LINE

Following the line down from the side of her head the numbers relate to where one section of line meets another. Sections of line are joined by sharp changes in direction as at points 1, 2, 3 and 5 or smooth curves as at points 4 and 6. Sections of line can be curved, straight or undulating around lumps and bumps. Pay as much attention as you can to the detail of each section of line and how it joins to the next section.

SUBTLETY OF LINE

The lines that you draw are often composed of many different sections of line, each of which needs careful consideration. Human bodies, for example, have edges or outlines that are subtle and complex, and often broken up by the lumps and bumps beneath the surface.

The different sections of a line are joined either by smooth curves or by a sharp change in direction at a particular point. It is essential not to confuse a change in direction for a smooth curve as this will dramatically change the look of a line.

The details and nuances of a line or a section of line are not difficult to see. The key is just getting into the habit of looking at whether, for example, a foot is joined to an ankle by a smooth curve or a sharper change in direction. As with all aspects of drawing, try not to assume anything, as what you see will depend completely on how you are positioned in relation to your subject.

The more you pay attention to where the lumps and bumps come along a line, how different sections of line are joined and the weight and nuance of curves – the more realistic your drawings will be.

Another example of how prior knowledge can affect the way that you see and draw is the tendency of the beginner to forget to draw curved lines at the bases of curved objects. Imagine that you are drawing a cup on a table. Usually, you are looking at the cup from slightly above it, as your eyes are above the surface of the table. The base of a round cup is a curved line. However, beginners may draw the base of the cup as a flat line as they know that the bottom of the cup is flat against the table. Critical seeing is the difference between drawing the bottom of the cup straight and drawing it as a curve.

DRAW BIG

In order to accurately depict subtlety of line, you need space. It's no good working on tiny little pictures in the middle of a huge expanse of empty space. So try and fill the page with your drawing. Draw big. Zoom in on your subject if you want – chop feet and heads off with abandon, at least while you're learning. Crop things to give yourself room on the page to add shade and colour without being cramped. If you draw too small you won't be able to depict subtlety of line with accuracy, and you won't have the space you need for the best shading and colour.

Tone

Shading gives drawings and paintings depth. We understand from our experience of the world that shadows appear on areas that are blocked from a light source, and anything that protrudes tends to have a shadow. Light tends to come from above so in general the areas of an object facing upwards will be lighter than the areas facing downwards. If you hold your arm out and look at it, most probably you will be able to see that it is lighter on the top than on the bottom.

If you bear in mind the principle that shadows happen in areas that are blocked from the light, you can start to predict where those shadows will appear, based on the shape of the object and the direction of the light source. But first you should just focus on examining what areas look dark and what areas look light.

In almost anything that you draw, there will be areas of it that will be in the light, areas in the dark and areas that are somewhere in between. Recognizing and dividing up what you are looking at into areas of light, medium and dark are key to shading.

One trick that can help you to recognize the lights and darks on an object is to squint your eyes when looking at it. This helps to increase the contrast slightly and it also takes away some of the line detail. Everything becomes a little blurry but none of the light information is lost.

When adding tone, it really helps to have the edges of your subject defined as much as possible. This is so that you can fill in the tone up to these edges and think afterwards about what is beyond them, and whether these areas are lighter or darker than the object itself.

Drawing round areas of light and dark can really help train your eye to look for tone and transfer that information to your drawings. If your darks aren't dark enough, this can push the whole tonal range of the drawing down, making it look flatter than it should. Having clear boundaries between different tonal sections, and thinking in advance about the shape of a shadow before filling it in, helps to negate this problem. Knowing where to stop shading will also help you have the confidence to shade the dark areas as heavily as they need. Planning like this also means that you can start to contour the shape of an object, without having to commit much pencil to paper. If something doesn't look right you can correct it easily.

Right: These images show different types of underdrawing:
1 Charcoal shading – filling in darks and using a rubber to create lights.
2 Contour lines – drawing around lights, darks and mediums and separating them with line.
3 Pencil drawing – filling in shading with pencil.
4 Charcoal drawing – different tonal areas are divided by lines and labelled with 'L', 'M', and 'D' (light, medium and dark).

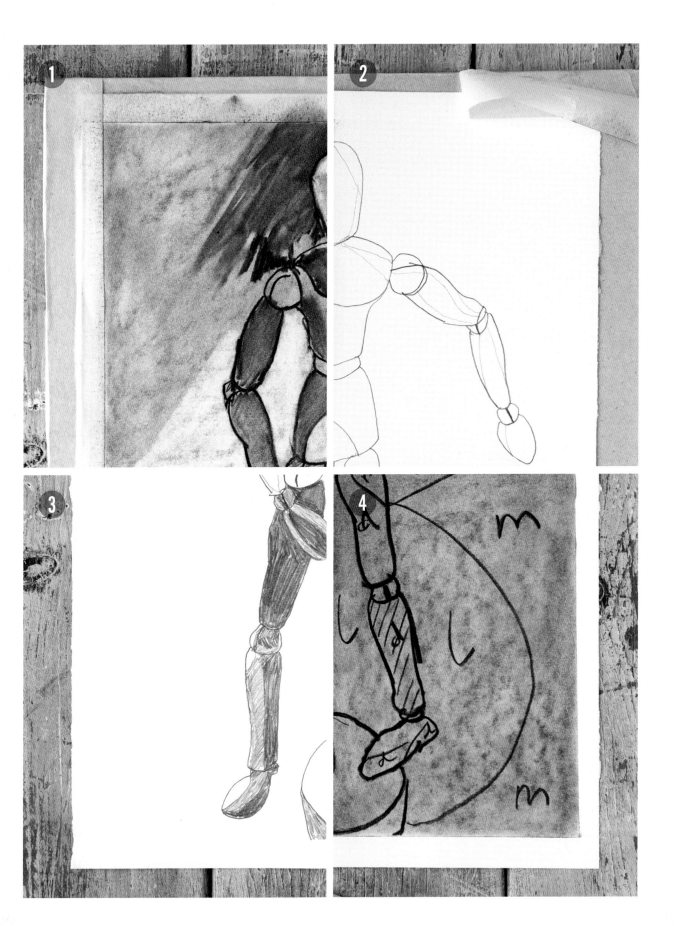

CREATING A SHADING PLAN

I always advise people to create a shading plan before actually filling in the different areas with different shades. When you have drawn the basic outline of your artwork, squint your eyes and look at your subject again. Look for three general shades – lights, mediums and darks. Draw around the outlines of the dark shadows and then the lights with as much accuracy as possible. What is left will be medium. You can then use this to guide you as you add shading to the drawing.

UNDERDRAWING V. PAINTING DIRECTLY ONTO THE SURFACE

The decision whether to draw first onto the surface on which you intend to paint is a stylistic issue and depends on what you are trying to achieve with the finished painting. If you want to create a realistic-looking figurative painting, drawing the subject first helps you to plan the composition in advance and allows you to rub out mistakes. You can also use underdrawing to plan where the main light and dark areas will be and generally block in the painting before you get started. The most common materials for underdrawing are pencil and charcoal (see illustration on page 97 for examples of underdrawing).

PRIMARY AND SECONDARY SHADING

Primary shading is shading the object itself; secondary shading involves shading the background where necessary. For example, when you are drawing a cup on a piece of paper, there might be areas of the background that look darker than the cup: therefore you will need to darken the background too. This secondary shading helps to make objects look three-dimensional. It's worth saying, though, that secondary shading is more about emphasizing the object that you are drawing by making its edges tonally different from the background. Don't detract from it by drawing too much detail in the background. You are always aiming for the same tonal jump between the background and object that there is in real life.

CONTRAST AND SMOOTH GRADATIONS

When shading, there may be areas of high contrast, where dark and light occur next to each other and the change is abrupt; in other areas, there may be a smooth gradient from dark to light with little contrast and much more of a gradual fade. Note where there is contrast and where something is smoothly faded from dark to light. In areas of high contrast, keep the differentiation between the dark and light as obvious and clear as possible.

DRAWING WITH A GRID

This is a powerful technique used by professional artists and amateurs alike. It is a simple way to get a proportionally accurate drawing from a photograph or any other two-dimensional image.

Essentially you overlay a grid on the image from which you wish to work, and draw a grid of the same proportions on the surface on which you intend to draw or paint. You then transfer the image square by square, i.e. the details of each square of the image are drawn or painted onto the corresponding square of the artwork. By breaking down the image into smaller sections it can make the drawing process more manageable. The grid can be as large or small as you like depending on how much accuracy you are after. The smaller the squares of the grid, the more accuracy it will give you when you come to transfer each square. (See illustration on page 101.)

Many professional photorealistic artists work in this way and sometimes they leave parts of the grid visible on the finished work for various stylistic and conceptual reasons. The contemporary portrait artist Jonathan Yeo, whose work is displayed at the National Portrait Gallery in London, uses this technique, leaving some of the grid visible on the finished piece.

EXERCISE: DRAWING WITH A GRID

You will need:

- ► sheets of acetate (available from stationers)
- ► scissors
- ► whiteboard pen (thin-nibbed)
- ► masking tape
- ► ruler (length dependent on the scale that you are working on)
- ► pencil or charcoal
- ► paper or canvas

1 Find a photo that you would like to transfer to a drawing or painting.

2 Put a sheet of acetate over the top of the photo and trim it down to size. Secure the acetate in place with small bits of masking tape.

3 Draw a grid over the top of the image on the surface of the acetate so as not to damage the actual image itself. (I often divide the image into eighths, but make the grid as small as you like.)

4 Make sure the surface that you are drawing on has the same proportions as the photo from which you are working; you might need to measure and trim your surface to match the proportions of the photo.

5 Draw a similar grid on the surface as you have drawn on the acetate on the photo – use fairly light lines so that you can erase them easily later. The grid needs to be proportionally identical.

6 Some squares with more detail can be double gridded (see illustration). This makes for a busier overall grid, but can be useful in squares where there is a lot going on.

7 Transfer the lines that you see in each box to your drawing, square by square.

8 Erase the grid on your own work when you have finished and are happy with the amount of detail that you have in your drawing (unless you wish to leave some parts of the grid for artistic effect).

9 If you intend to add paint to your drawing and are continuing to work from the photo, it can be a good idea to remove the acetate grid at this stage so that you can see the photo clearly without the grid over the top.

▼ **Draw from memory.** This one is pretty self-explanatory but it can be difficult to decide what subject to choose. I had a friend at art school who used to draw his childhood houses from memory down to the tiniest detail, such as what was next to the television and how the fireplace looked. It's often surprising what you can remember when you try. Drawing from memory will inevitably be less photorealistic than if you have the subject in front of you, but that is exactly the point.

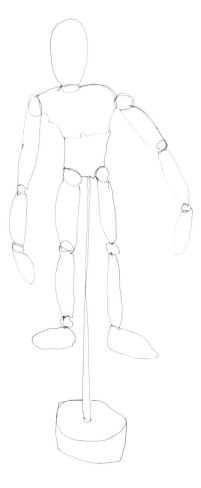

Draw something you'd normally dismiss or think inappropriate as the subject of a piece of art. Like most people, you might have fairly set ideas about what constitutes an appropriate subject for a drawing. Try and break free of these traditional ideas and think of something that is inappropriate or unworthy of being the subject of an artwork. This might be something you take for granted in everyday life but would never normally think of drawing, or just something ugly or difficult to draw. Examples might include: your Facebook page, including all the windows and sidebars; the title of a magazine lying on the table in front of you (not the magazine itself but just the text of the title); or your gaudiest, tackiest or most despised ornament that you just can't bear to get rid of because of its sentimental value.

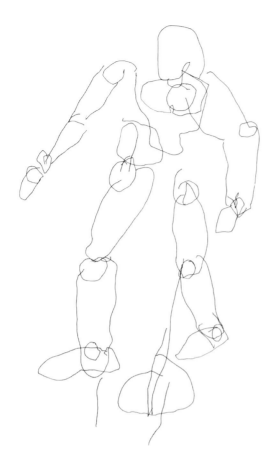

▼ Hold the pencil with your less dominant hand. This means drawing with your left hand if you are right-handed or vice versa. Most people baulk at this when I first suggest it and think that they won't be able to do anything but a scribble. However, you may be surprised by how much you can do with your weaker hand. It's a really good exercise for helping you to consider the kind of mark that you are making or the quality of the line you are using. This is because you have much less control with your weaker hand and you have to try harder just to manipulate the pencil.

▲ Draw without looking at the page. You will have to fight the urge to look – most people sneak peeks instinctively. The key here is to relax and focus by staring at the subject that you are drawing. The result might mean that the different sides of an object do not match up, and you might end up in completely the wrong place with a line, but it's a great exercise for helping you to be less precious about what you are drawing and to focus on just your hand/eye coordination.

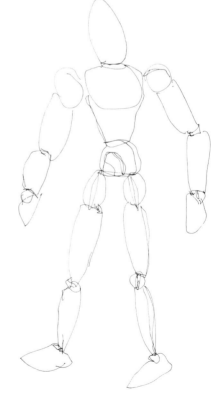

Not taking the end of the pencil off the paper. This is sometimes called 'taking the line for a walk'. It forces you to draw something with one line so that all parts of the thing are connected. It makes you come up with interesting solutions to capture a three-dimensional form in two dimensions and encourages an inventive quality of line.

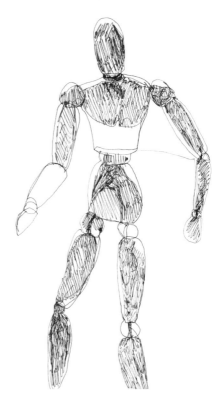

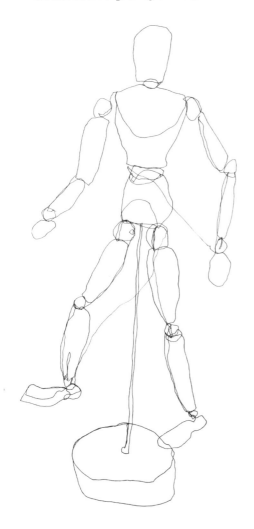

Give yourself time limits. You can give yourself between 30 seconds and 15 minutes to draw something. Having less time means that you have less chance to question yourself and have to get the marks down on paper. This is a common technique used in life-drawing classes, where the model is told to only hold a certain pose for a short amount of time and then move so that you have to try and capture the pose very quickly. This encourages you to edit out unnecessary information and just think about which lines are essential for capturing a pose quickly. I often tell people to try and capture 'the spirit of the pose' – the essence of the pose.

Loosening Up

These exercises are to encourage different ways of seeing and thinking, and to prompt you to use different types of line. Your drawings and paintings might get a bit stale if you just create things in the same old way that you always have, so these exercises are designed to shake things up a bit and force you out of your comfort zone. Some of them might seem a little strange at first, but give them a try and see what happens ...

▶ **Draw only the shadows.** This works best in quite strong lighting so that shadows are quite well defined, dark and easy to see. Squint your eyes if it helps and see how much you can capture a face, still life or landscape by only drawing the shadows as opposed to the lines and edges of the forms themselves.

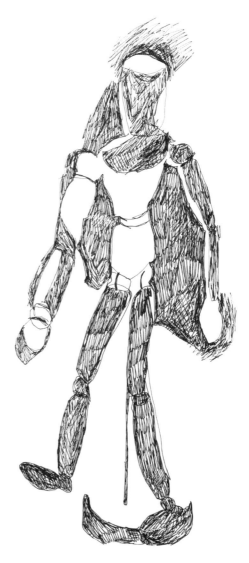

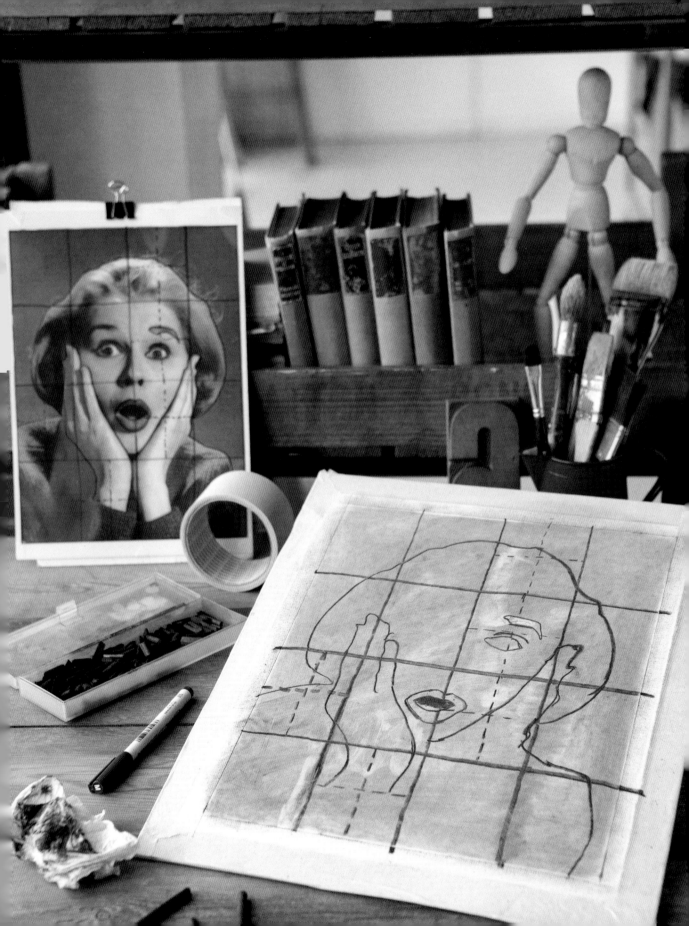

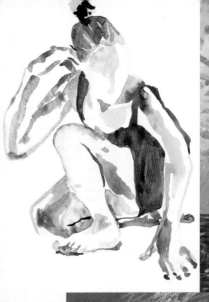

STILL LIFE

Still Life

When creating still-life compositions it is best to start simply, working from just one or two objects. Focus on capturing the form and shading (light and dark) of those objects and the shadows they leave on the surface on which they are resting.

Working from just one or two objects means that you can draw the objects larger than life size, which is good for giving yourself space to pay attention to the lights and darks of an object, its exact shape and how the light falls around it.

Later, when you feel more confident, you can put together a group of objects that are a similar colour, and focus on finding ways to highlight the subtle differences in colour, shading and form.

You can experiment with traditional objects, such as flowers and fruit, or more contemporary objects, or you can mix the two. It can be fun to group objects together in interesting ways, for example different types of object that perform the same function but come from different eras, such as a candlestick, a gas lamp and a light bulb. Think about depicting contemporary objects that you use in daily life but have never seen represented in still life before.

IDEAS FOR BEGINNERS

▸ Avoid glass, as reflections are difficult to master.

▸ Draw larger than life size so you can focus on accuracy of form.

▸ Try starting in charcoal on a charcoaled background and working with a sharp eraser, which will help you represent light and dark and rub out mistakes.

▸ Look for the objects' shadows and draw around the edge of them before filling them in.

IDEAS FOR THE MORE CONFIDENT

▶ Think about background and surface; you can add interest and colour by placing objects on a patterned surface such as a striped tablecloth or draping a patterned cloth across the background of your composition.

▶ Incorporate glass bottles or glasses half-filled with water. Glass poses two challenges: firstly, it is reflective and, secondly, it can distort what is behind it (and water in a glass can make the distortion greater). See page 126 for an example.

▶ Find something metallic and try to capture the reflections on the surface.

KEEP IN MIND ...

▶ **Shadows:** All objects cast shadows on the surface on which they are resting and will often appear to be dark at the base where they meet the surface. These shadows play a large part in our understanding that an object has volume and weight, as without them the object will look like it is floating and flat.

▶ **Round bottoms:** The base of anything that is cylindrical or round like a glass or a flower pot will have a curved base where it meets the surface. Remember not to draw the bottom of round things as flat.

▶ **Reflective items and water:** The key to capturing the reflections and distortions that water creates is to look for the different areas and shapes of colour in that surface and recreate them as realistically as possible. It really helps to draw around the different shapes first (see the project on page 126).

Orange on table

Estimated time: 1 hour
Medium: charcoal
Surface: paper
Difficulty rating: 2

You will need:
▶ an orange, A3 paper, a stiff board, masking tape, charcoal, a cloth or duster and a retractable rubber or the rubber on the end of a good-quality pencil

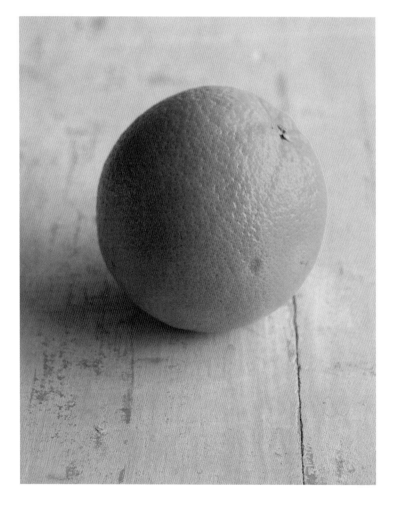

1 POSITION YOUR OBJECT

Put an orange on the table in front of you in a space with a good amount of natural light, if possible. Prepare a mid-grey charcoal background (see page 38). Set up your materials and easel, if you have one (just work flat on a board if you don't), so that you can comfortably see both the subject and your drawing at the same time.

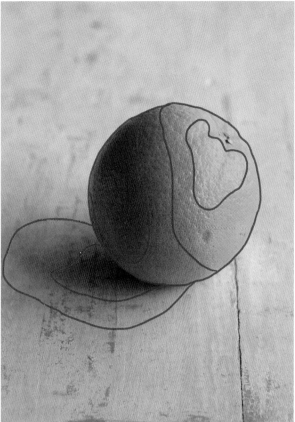

2 DRAW AN OUTLINE

Start by drawing the outline of the round shape of the orange as best you can, paying attention to any lumps, bumps and irregularities in the shape. Get the stump of the stalk roughly in place, paying close attention to how far it is from the outline. By working like this in charcoal on a mid-grey background, you should be able to rub away lines with your hand if you make a mistake so there is no need for a rubber until you start shading.

3 FIND THE MAIN AREAS OF LIGHT AND DARK

Look at your orange and think about where the main lights and darks are, and where the light is coming from. The orange in the photo is on a table next to a window so the strong light is coming from the right. This means that the orange looks lighter on the right than on the left. The pink lines roughly divide the areas of different tones, including the shadow the orange leaves on the table. These lines are the basis for the shading plan.

4 DRAW YOUR SHADING PLAN

Draw around the areas of light, medium and dark in the orange outline you have drawn. Also draw around the outline of the areas of shadow on the table, ready for filling in.

5 SHADE THE OBJECT

Shading of the object itself is called **primary shading** and the shading of the background is called **secondary shading**. Now use your charcoal to fill in the dark and medium areas of the orange, blending the charcoal with your fingers so that it looks fairly smooth. For the light areas, such as near the top of the orange where light is reflecting off the shiny surface, use a rubber to remove the mid-grey surface charcoal. In the original photo, notice that the bottom left-hand edge of the orange is slightly lighter than the table.

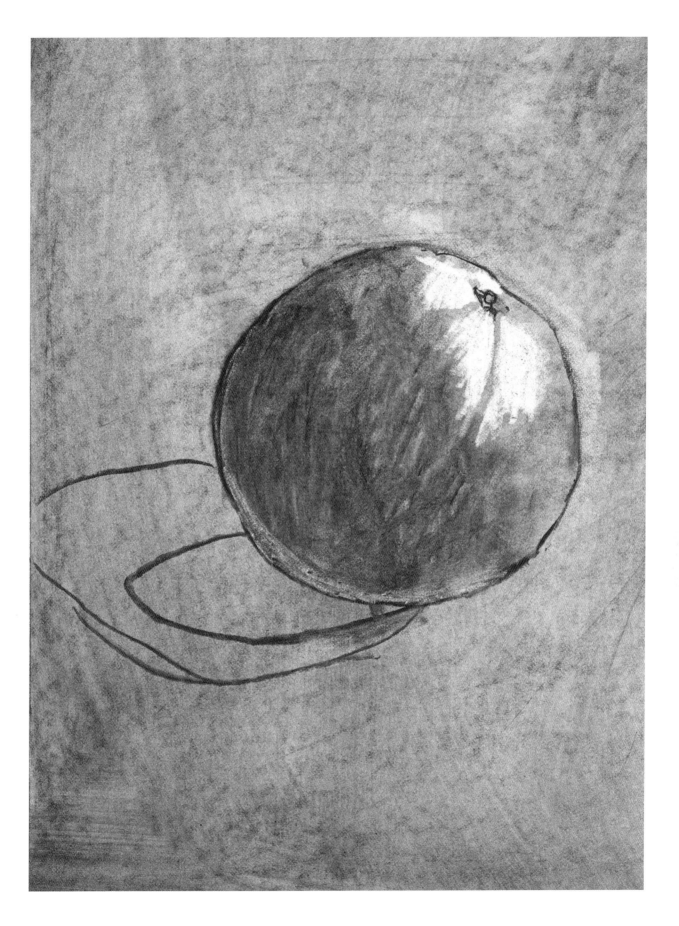

6 SHADE THE BACKGROUND

Now it's time to fill in the shadow and work on the secondary shading. Notice that the shadow is darkest closest to the orange and it fades out further away from the orange. Fill in the dark and medium sections of the shadow with charcoal according to your plan. Then it is time to work on the rest of the background.

When thinking about secondary shading, always consider whether the background looks darker or lighter than the object. There is usually some variance: the background will look darker in some areas and lighter in others. Remember that the shadow on the table looks darker than the bottom of the orange.

In order to lighten the background, erase away the mid-grey using a rubber. Pay attention to any areas that look particularly light, and establish those light areas first. For example, the lightest area of the background of the photo is close to the orange on the upper left-hand side, so get this in first.

Look for areas of high contrast to help you identify the lightest areas of the background, i.e. the upper left-hand side of the orange looks very dark compared with a very light background. This is an edge of high contrast and so provides a clue that the background in that area will need to be particularly light.

The key to secondary shading is paying attention to the contrast between the object and the background, and understanding that this will vary all around the object.

I have added a little bit of charcoal to darken the background slightly just next to the lightest part of the orange: this accentuates the edge in that area. I have also adjusted the primary shading in this area by adding a little more light along the edge of the orange itself.

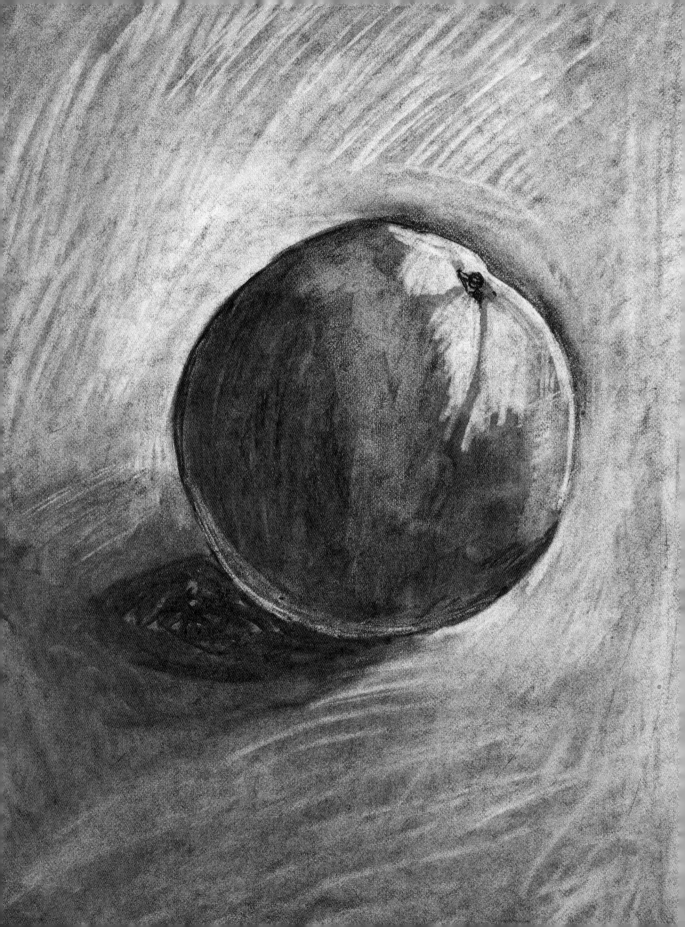

Three simple objects

Estimated time: 3 hours
Medium: dry pastel
Surface: paper
Difficulty rating: 3

You will need:
► three objects, A2 paper, masking tape, a stiff board, charcoal, a cloth or duster, a sharp rubber, assorted pastels and, if possible, blending sticks

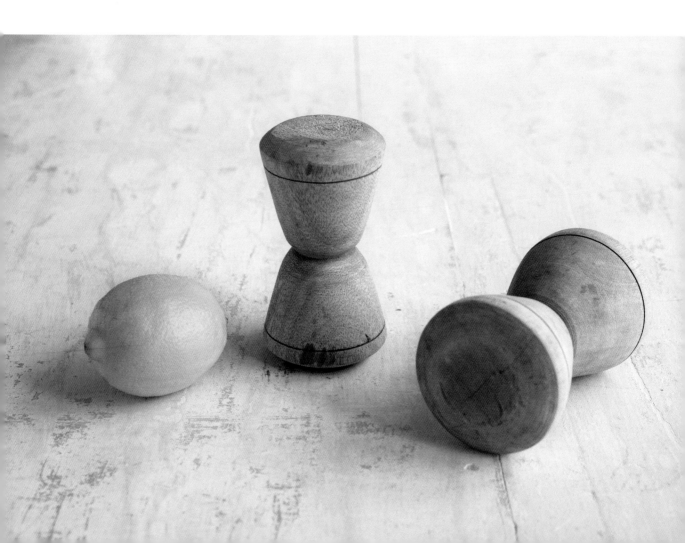

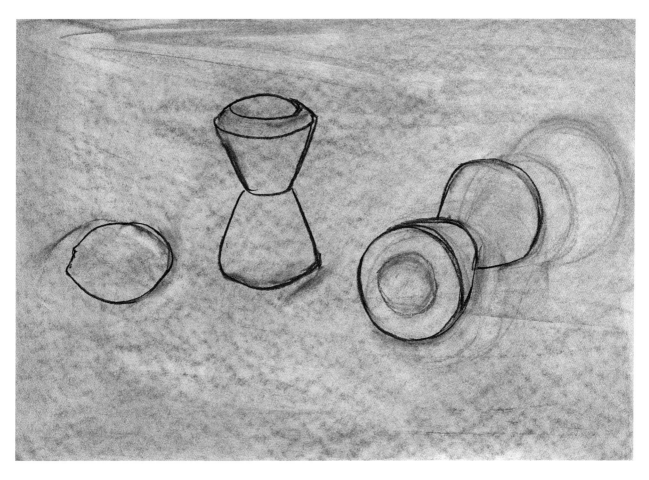

1 ARRANGE YOUR OBJECTS

Set up some simple objects in an area with lots of natural light and prepare your mid-grey paper (see page 38). Set up your materials and easel, if you have one (just work flat on a board if you don't), so that you can comfortably see both the subject and your drawing at the same time.

2 DRAW THE OUTLINES

Draw the outlines of your objects, paying attention to the negative space between objects to help place them correctly in relation to each other.

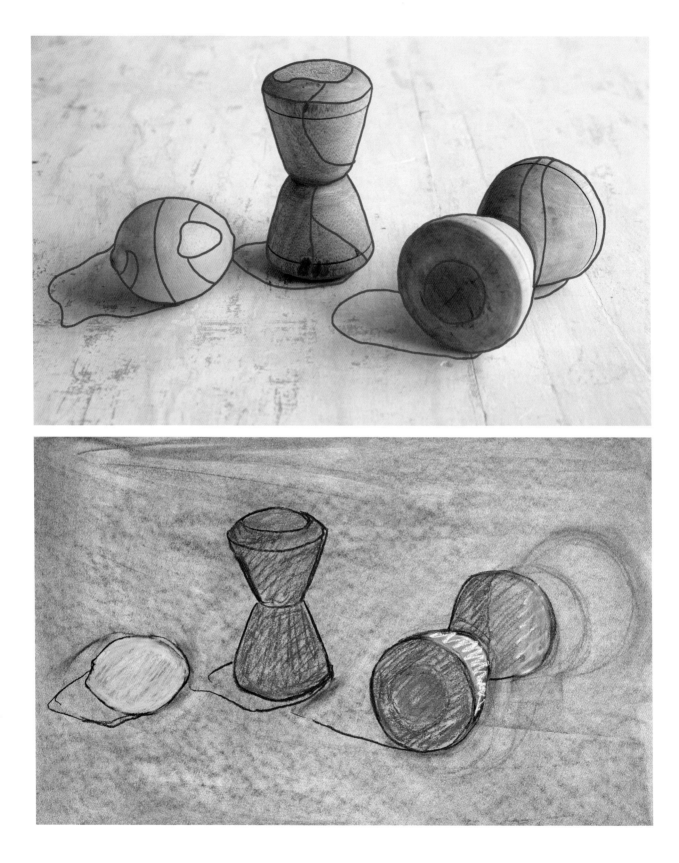

3 FIND THE AREAS OF LIGHT AND DARK

Look out for the areas of light, medium and dark on each of the objects, and look for their shadows. The pink lines in the photo roughly break up the areas of different tone within the outlines of the objects.

4 BLOCK IN THE MAIN AREAS OF COLOUR

This can be done quite roughly at first – you are just trying to get an idea of which colours you are going to use by blocking in the objects with midtones. Notice that a blue pastel is layered over the top of an orangey-brown in order to get a dark brown.

5 BLEND IN THE MIDTONES

Use your finger to blend the midtones and get an even tone in all the main areas. If you have a blending stick, use it to blend any tricky areas that are too small for you to blend with your finger.

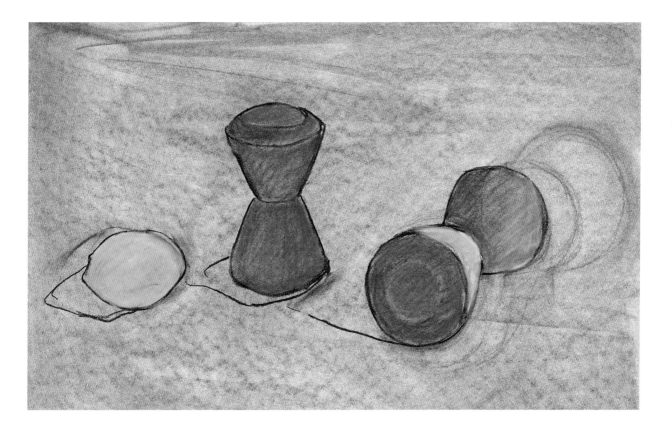

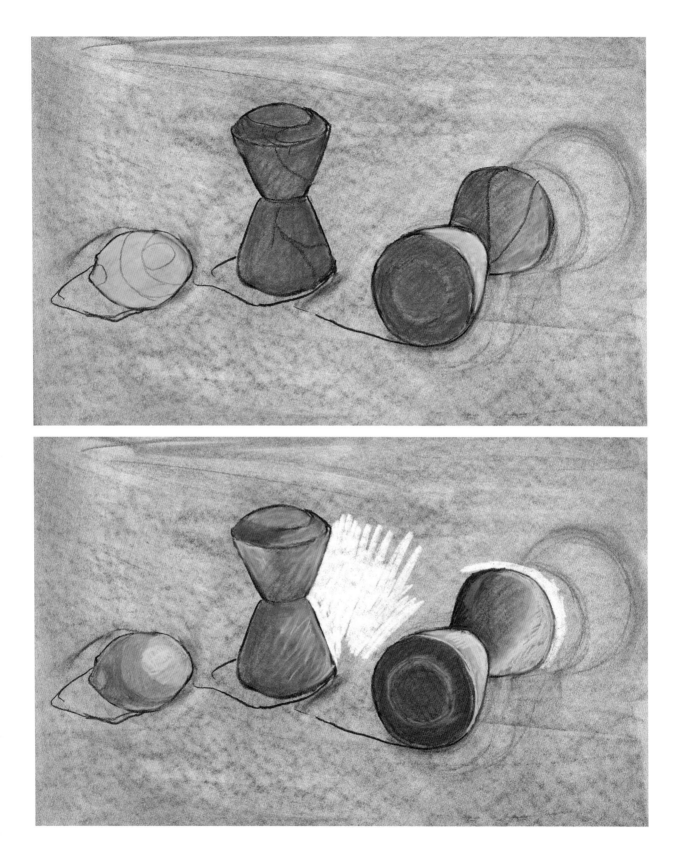

6 DRAW YOUR SHADING PLAN OVER THE MIDTONES

On top of the midtones, draw light charcoal lines round the outlines of each area of light and dark. This is your shading plan.

7 ADD DARKS AND LIGHTS TO OBJECTS ACCORDING TO YOUR SHADING PLAN

Fill in the lights and darks on each of the objects by layering darker or lighter colours on top of the midtones. For example, on the lemon I added blue, pink and yellow on top of the midtone yellow to darken parts of it. I added a whitish pastel on top of the midtone for the lightest part. You can also see that I have started to lighten the background by erasing it.

8 FILL IN SHADOWS AND ADD SHADING PLAN FOR BACKGROUND

Fill in the shadows on the tabletop background with charcoal. Notice that some areas of the shadows are lighter than others. Remember that squinting your eyes can help you to see lights and darks better. Plan how you will erase the rest of the tabletop by dividing it into areas of light, medium and dark – you can label them with letters if this helps. Looking for areas of high contrast between the edges of the objects and the background can help you to notice which parts of the background need to be lightest.

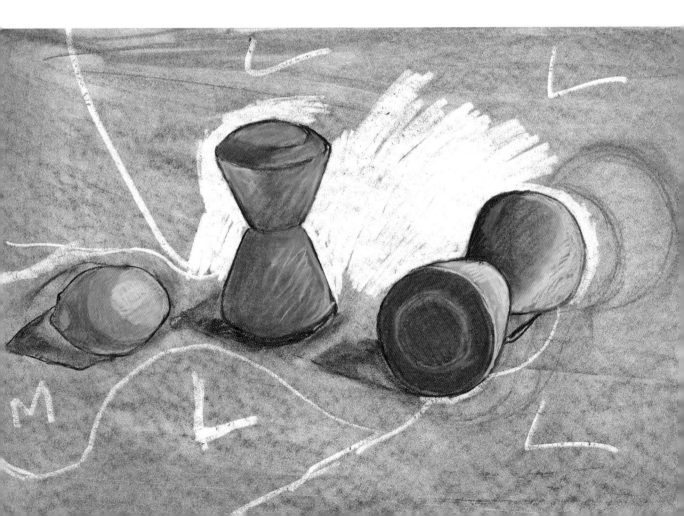

9 FILL IN SHADOWS AND LIGHTS ON BACKGROUND

Finish the tabletop by erasing according to the shading plan. You can blend the erased sections as much or as little as you like. I have left mine fairly textured by not blending too much.

Adjust the shading if necessary. For instance, I needed to add more shading along the bottom left-hand side of the central object. Blend the borders between lights, mediums and darks in the places where there should be a smooth gradation. Again, how much you blend is up to you but make sure that you do not blend between areas of high contrast.

Finally, add all surface detail such as the lines around the tops of the grinders and the line of the join in the tabletop.

Complex still life

Estimated time: 5 hours
Medium: acrylics
Surface: paper
Difficulty rating: 5

You will need:
▶ a range of different objects with different textures, complex surfaces and reflections, A2 paper, a stiff board, palette, charcoal, pencil, acrylic paints and brushes

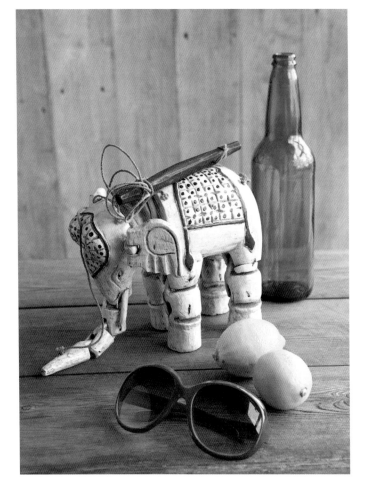

1 ARRANGE YOUR OBJECTS

Choose a location with a lot of natural light. Carefully consider the background and surface upon which they are resting. Prepare some mid-grey paper (see page 38). Set up your materials and easel, if you have one (just work flat on a board if you don't), so that you can comfortably see both the subject and your drawing at the same time. Don't prepare your palette until you are ready to start painting.

2 DRAW THE OUTLINES

Fill in the outlines of your objects. Remember to look at the negative spaces between the objects to help the placement (also look at pages 87–88 to see how imaginary vertical and horizontal lines can help).

You don't need to bother putting in most of the surface detail at this stage, e.g. the markings on the elephant's body will be added much later. However, notice that I have already drawn in the outlines of the reflections in the lenses of the sunglasses as they are fairly simple shapes – I decided that I would not need to work in layers for this, which is what we will need to do to capture the more complex reflections on the bottle.

When you have finished your drawing you are ready to prepare your acrylic palette (see page 53 for help with this).

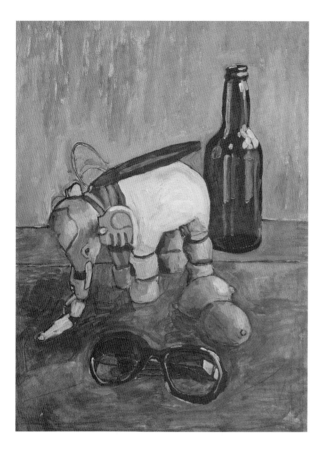

For the background, mix a dark, medium and light bluey-grey. Working with a medium-sized brush in downward strokes, cover the background area fairly roughly, switching back and forth between colours as you go. Leave a little of the background showing through for texture and movement.

8 ADD FINAL DETAILS TO TABLE AND ELEPHANT

This is the finishing stage in which you add all surface detail and make any final adjustments.

Using a pencil, draw the outlines of the large shapes of pattern on the back and head of the elephant. Mix a dark and light red colour and, using a fine brush, add the detail along with the black dots.

For the strings, you will need dark, medium and light browns, applied with a fine brush. Look closely at the strings against the background: some sections look darker or lighter than the background, so paint them accordingly as best you can.

Add any final touches, for example to the surface of the table. I also added some more shadow under the glasses, the elephant and the lemons, as well as the final horizontal join line that runs all the way across the table.

7 ADD SURFACE AND BACKGROUND DETAIL

Make a rough shading plan for the tabletop by looking for the shadows of the individual objects and drawing around them. Mix a light, a medium and a dark brown for the tabletop. Fill in the shadow outlines with dark brown. Next, draw around the lightest areas of the table, for example towards the right of the objects. Paint in these areas with light brown. Then fill in all the remaining areas with your mid-brown. You will need to work fairly quickly so that the colours remain wet and blendable, but you can always add more colour over the top later if you have left out any shadows or need to adjust the shading of the table.

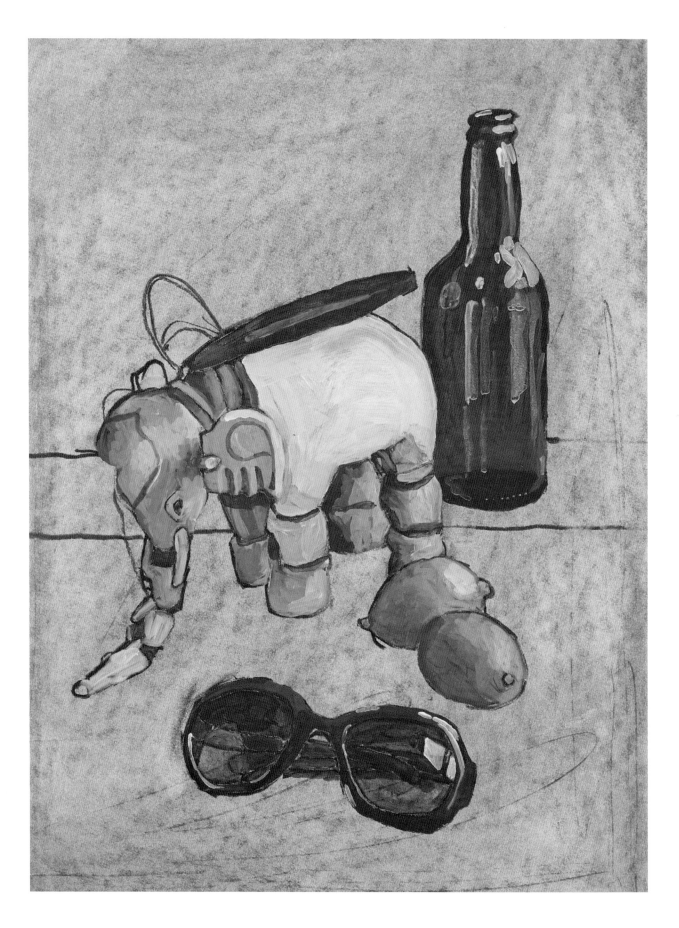

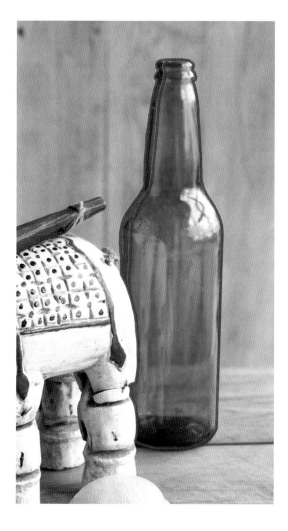

5 FIND FURTHER AREAS OF TONE

This image (left) shows the main areas of dark and light in the bottle. The surface reflections have been excluded because they need to be layered on top of these areas of different tone once they are dry.

6 ADD REFLECTIONS TO THE BOTTLE AND SUNGLASSES

For the reflections on the bottle, you will need to mix some light greens, blues and off-whites for highlights.

Try using some of these colours with a fairly watery consistency so that the paint is transparent. Paint these colours in streaks over the basic tones that you added earlier. After they have dried, check to see if these light streaks are obvious enough. If they are not, the paint was a bit too thin. You can always go over them again.

For the sunglasses, you will need some light greys and white. Add these colours to the reflection shapes on the lenses and in streaks on the frames using a very thin brush for the highlights.

3 FILL IN MIDTONES FOR THE MAIN AREAS

Block in the main areas of colour: the different parts of the elephant's body and handle, and the bottle, lemons and glasses frames. What you are doing here is sometimes referred to as **underpainting.**

Block in the lemons with a mid-yellow, the bottle with a mid-green and the glasses frames with a mid-red.

The elephant is more complicated because it is composed of many different sections and each of these requires a different base/block colour. I divided it roughly into body, legs, head, neck, trunk and handle.

When you begin to paint the elephant, I would suggest just mixing a light grey, a medium grey and a dark grey because acrylic paint dries quickly. You can block in the body with the light grey, the head with the dark grey and the trunk with a medium-grey mixture between the two. Next, mix a black and fill in the legs with the various greys and black. Blend as you go along.

You can use the black to block in the handle, while the neck needs to be blocked in with brown. Be careful to leave the different sections clearly differentiated.

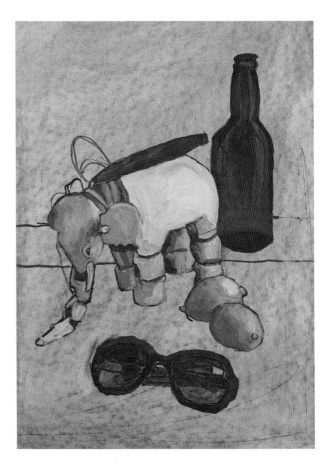

4 ADD LIGHTS AND DARKS TO THE OBJECTS

Mix light, medium and dark versions of the block colours for each of the objects and add them to the painting for the highlights and shadows (at this point do not add the surface detail such as the reflections on the bottle and sunglasses lenses). To help, you can use a shading plan by drawing around the light, medium and dark areas on each object and on each part of the elephant.

I would advise getting as far as you can with one object before moving on to the next because acrylic paint dries quickly and you will need to blend the colours.

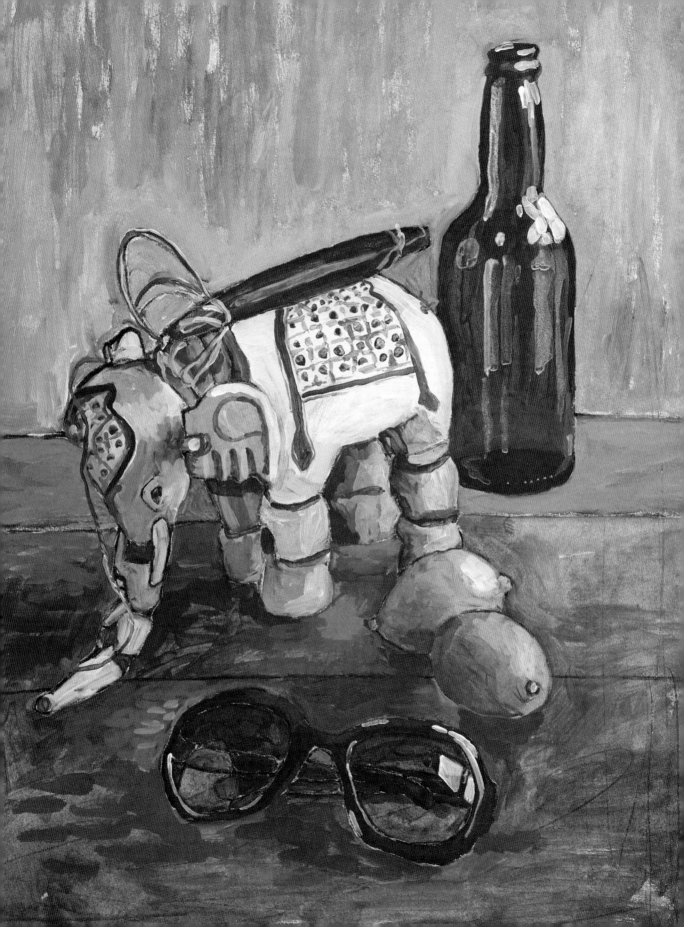

LANDSCAPES

Landscapes

When you create a landscape, the aim is to create the illusion of depth within the artwork. There are several main techniques for doing this and, once you understand them, you will notice their use in the vast majority of landscapes.

The first technique is decreasing scale. This simply reflects the fact that objects in the foreground seem larger than objects that are further away, i.e. the closer we are to something the bigger it will look to us.

The second is overlapping forms. When one thing is in front of another, the thing in front might partially obscure the thing behind so they appear to overlap.

The third is fading colours and clarity. You will often notice that the background of a landscape appears lighter and more washed out than the foreground. The background may also lack focus and intensity as if the painter was struggling to see it clearly or the far distance was obscured by mist or an abundance of light.

Leading lines are often used in landscape painting to guide the viewer's eye into or across the painting in a certain way, i.e. they are a compositional tool but they are also often influential in the creation of depth. A leading line is often a path or road but it could be a river that winds its way into the painting from the foreground to somewhere in the background. It appears wider in the foreground and gets smaller as it recedes into the distance, thus giving the illusion of depth.

LIGHT AND DARK TONES

When you want to create either depth or atmosphere, or both, it's important to appreciate where the main light and dark areas are within a landscape. Remember, if you squint your eyes you will get a better idea of where the main areas of light and dark are in any scene.

Generally in landscape painting, water and sky emit light while anything large and imposing in the foreground tends to look darker. Water usually reflects the sky, which is why it is often a source of light. However, remember that it can also reflect anything that is around it, including darker features such as trees and buildings.

IDEAS FOR BEGINNERS

▶ Include significant features in the foreground as well as the background, rather than just concentrating on features far away in the distance. This really helps with the creation of depth and will help you to get to grips with decreasing scale.

▶ Work on medium-coloured or dark paper with both dark and light pencils. This is a great way to be able to quickly depict areas of light and dark to get a sense of the main tonal composition of a landscape (see the project on page 142).

▶ Practise depicting texture and direction with different types of mark; the angle of stalks in a field of corn, for instance, may be different from a set of fence posts.

IDEAS FOR THE MORE CONFIDENT

▶ Think in terms of layering and overlapping forms. For example, you might colour the sky behind a tree first, then draw the trunk of the tree, and then add leaves or clumps of leaves individually over the top to partially obscure the sky and the trunk.

▶ Try and depict water in the form of a pond or river and really pay attention to the darks and lights reflected in it.

▶ Use individual brush marks to depict leaves or the texture of the surface of water.

▶ Work from real life as opposed to photos – a photo is already flat so it is easier to work from than a three-dimensional landscape but working from real life gives you much more control.

Close-up of a flower

Estimated time: 1 hour
Medium: water-soluble pencil
Surface: white paper
Difficulty rating: 4

You will need:
▶ board, white paper, masking tape, a pencil, water-soluble coloured pencils, a pointed watercolour brush, a pot of water

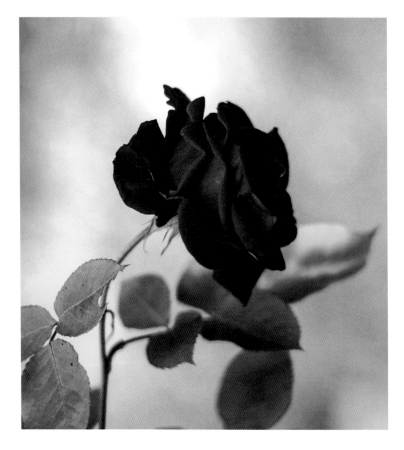

This project is all about observational detail. You can either work from a photograph, as I have done here, or work from life.

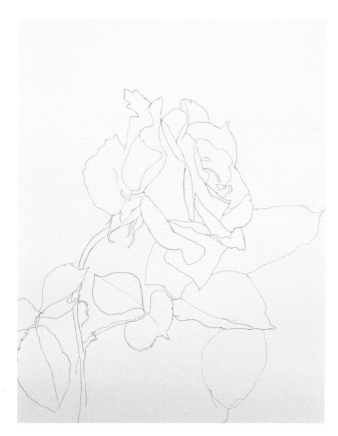

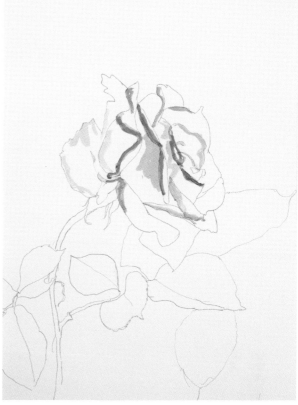

1 DRAW YOUR OUTLINE
Using a normal pencil, draw in the outlines of the flower as much as you can.

2 ADD THE LIGHTEST COLOURS
Painting flowers is all about capturing the contrast between the lights and darks of the individual petals. When you are working in water-soluble pencils, as you are here, it is important that you carefully plan which areas you need to keep the lightest, and you should add these first. When looking for which areas to leave lightest, it often helps to find the areas of high contrast, i.e. where there are crisp dark edges against light areas.

I painted these initial light areas on with a paintbrush instead of drawing straight onto the picture because I wanted to be able to control the colour very precisely. To do this, draw patches of colour on a separate sheet of paper and add water. Then use the paper as a palette and apply the colour with a brush.

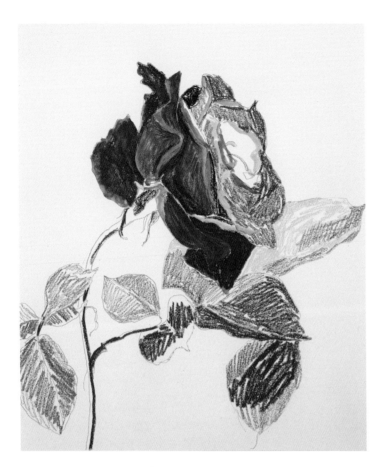

3 ADD MEDIUM AND DARK COLOURS

Once you have blocked out the areas that need to be kept the lightest, you can add the medium and dark colours with the water-soluble pencils directly onto the picture itself. This will give you the same sort of stroke marks as drawn works.

It is possible to layer water-soluble colours. For example, in the central area of the rose I added some dark blue over the pink where I wanted to darken it.

It's crucial, wherever possible, to look at each petal edge against another. We only see things as separate from each other if one thing is lighter, darker or a different colour to the thing next to it.

Add water with a brush as you go along (rather than adding it all at the end) to get a feel for how the water changes the look of the work. Adding it gradually will give you more control.

4 ADD FINAL DETAILS

Notice the shading on the stalk: I only coloured one side of it with a dark olive-green water-soluble pencil. This meant that when I added water to it with a brush, I could fill in the light green on the other side of the stalk by just using the colour that was left on the brush when I wetted the dark side.

A lake scene

Estimated time: 1 hour
Medium: black pen and white pencil
Surface: midtone paper
Difficulty rating: 3

You will need:
► midtone paper,
a thin-nibbed drawing pen,
a white pencil

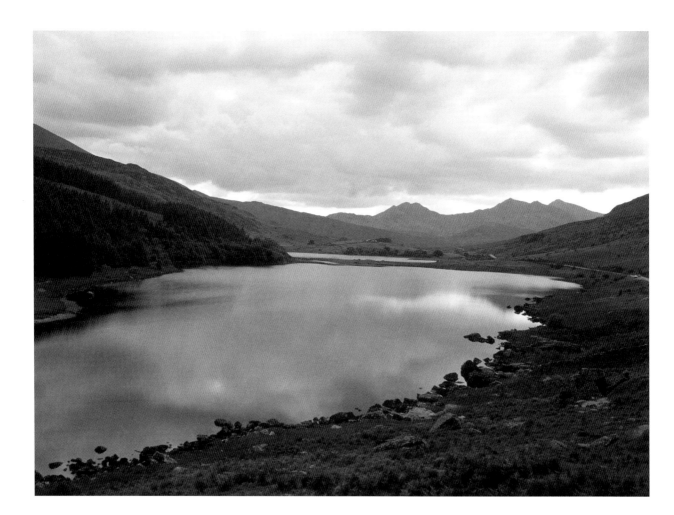

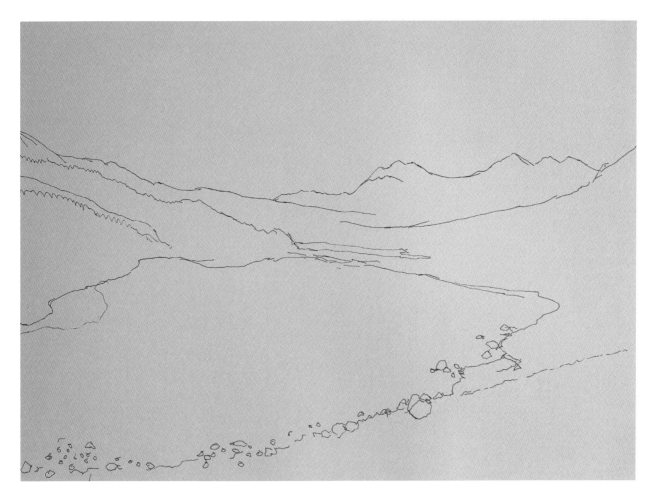

*The idea of this exercise is to show
you how quickly you can build up an
apparently three-dimensional landscape
when working with both dark and light
pens and pencils on midtone paper.*

1 DRAW YOUR OUTLINE

Using a thin-nibbed drawing pen, draw
the outlines of the mountains, lake and
boulders in the foreground.

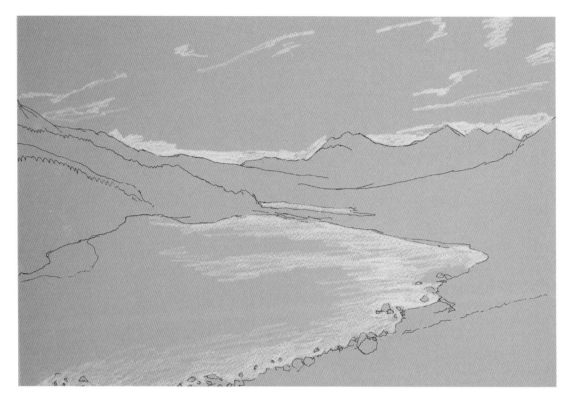

2 ADD WHITE TO SKY AND LAKE

Using either a white pencil or a white pen, start adding white to the lightest areas of the lake and sky. Notice that this almost immediately adds depth by defining the mountains as separate from the sky.

3 CONTINUE ADDING WHITE TO SKY AND LAKE

Think about the direction of your stroke as you continue adding white. For example, in the top right image you will see that I have used a more or less horizontal stroke for the surface of the water because it is flat. For the sky, which is more textured, I have used an angled stroke with more variation.

4 FILL IN FOREGROUND AND BACKGROUND

Using the black pen and working fairly quickly to get a scribbly effect, fill in the darkest sections to the left of the lake and in the foreground. Change the direction of the stroke to create texture. Then use a less dense stroke mark for the mountains in the background so that they appear lighter. I have also added some more white to the lake to balance the shading.

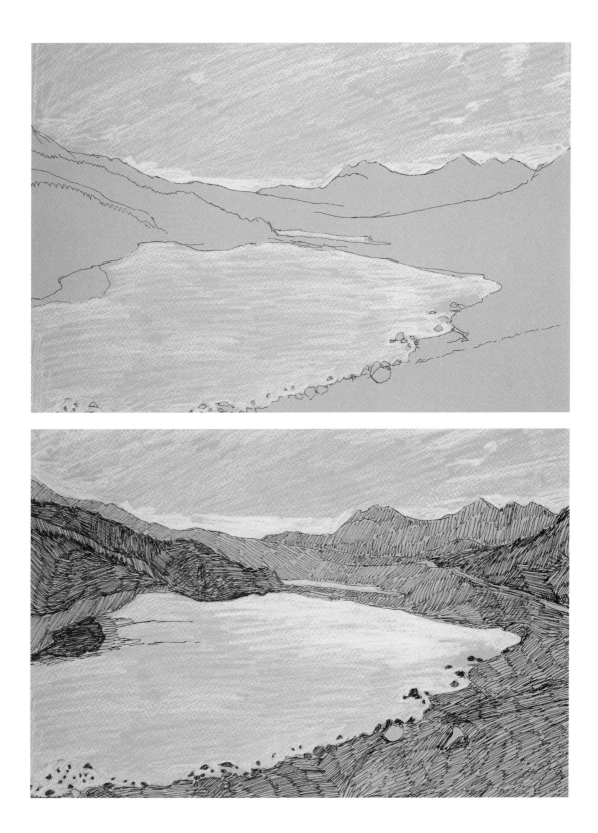

5 BALANCE THE SHADING

You need to make sure that the difference between the darkness of the foreground and the background is correct. In order to balance the shading, I darkened the whole of the foreground further by adding another layer of marks to the swathe of land at the front and the nearest hills on the left. I also added another layer to the background mountains but I made sure that the foreground remained darker overall.

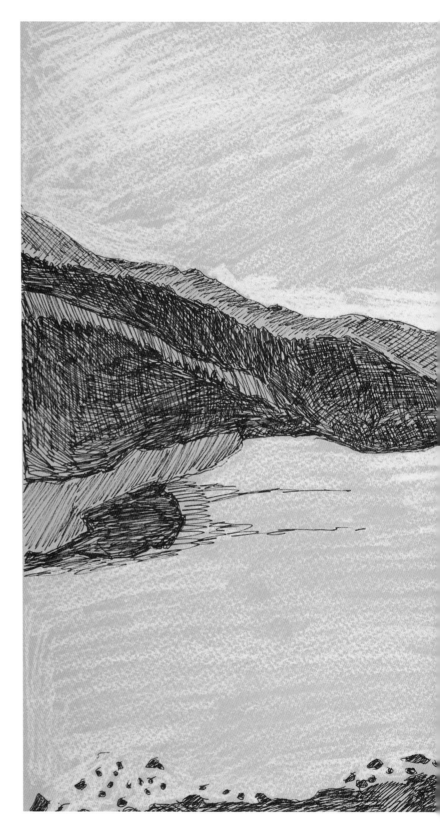

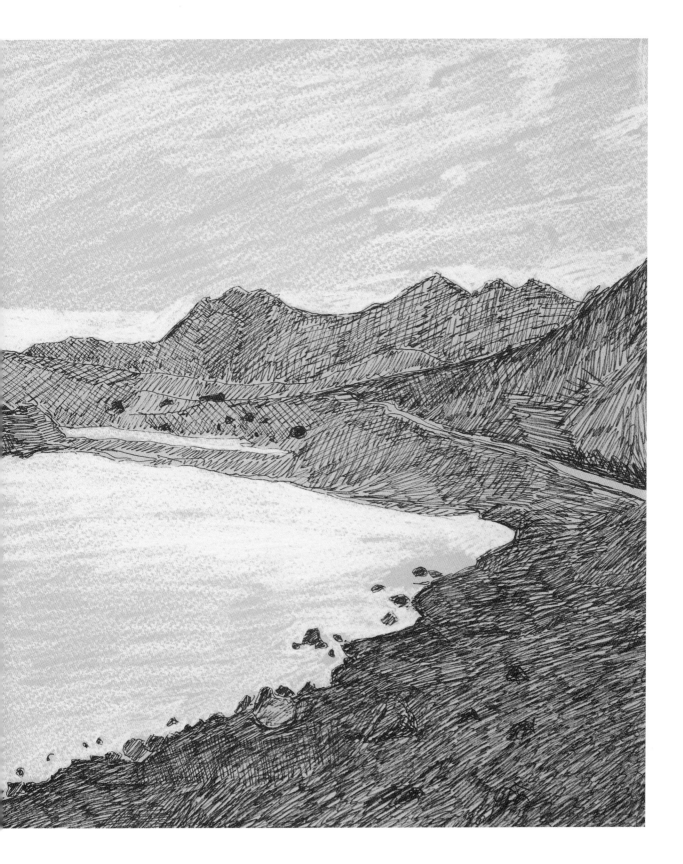

Alnwick Castle

Estimated time: 2/3 days including drying time
Medium: oil paint
Surface: primed canvas
Difficulty rating: 5

You will need:

▶ canvas primed with clear primer, a pencil, large, medium and small round-ended brushes, a small pointed brush, a selection of oil paints, a jar of medium, an oil palette, rags for wiping

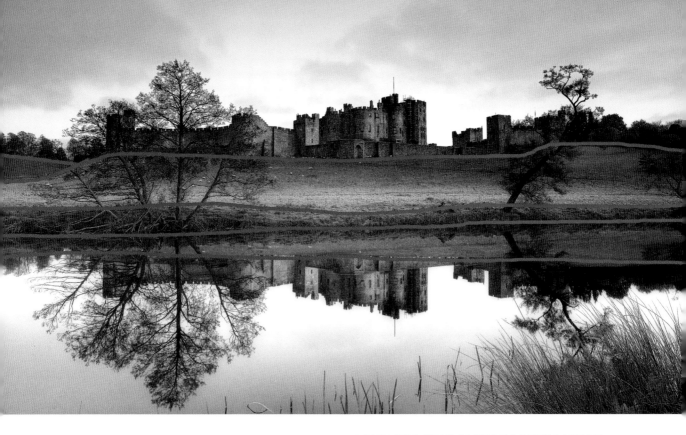

This project will build on the techniques you have learned from the previous projects, by combining focus on detail and creating a sense of depth in your artwork.

1 FIND THE MAIN SECTIONS OF THE IMAGE

The first thing to do with a landscape like this is to break it up into its main sections, discounting any surface detail. To help plan my initial sections, I laid a sheet of acetate over the image and traced on top of the outlines with a whiteboard pen.

2 OUTLINE MAIN SECTIONS FOR UNDERPAINTING

Use a pencil to transfer the outlines of the main sections to the canvas. I used a natural linen canvas primed with a clear primer to give me a mid-colour surface to start on. You are now ready to prepare your oil palette (see page 18).

3 UNDERPAINTING STAGE 1: FILL IN COLOUR

Block in the different sections roughly with the right colours. Try to put in place any gradations as much as possible, such as the dark sky at the top fading to light near the horizon.

4 UNDERPAINTING STAGE 2: ADD DETAIL TO SKY

In order to make the clouds look a bit more realistic and to add detail to the sky, mix some greys, pink and pale pastel oranges. Use a largish brush without much paint to streak these different colours over the right side of the sky in wavy strips. Then, again using the largish brush and not much paint, add the greys to the left side of the sky and across the bottom of the reflection in the lake.

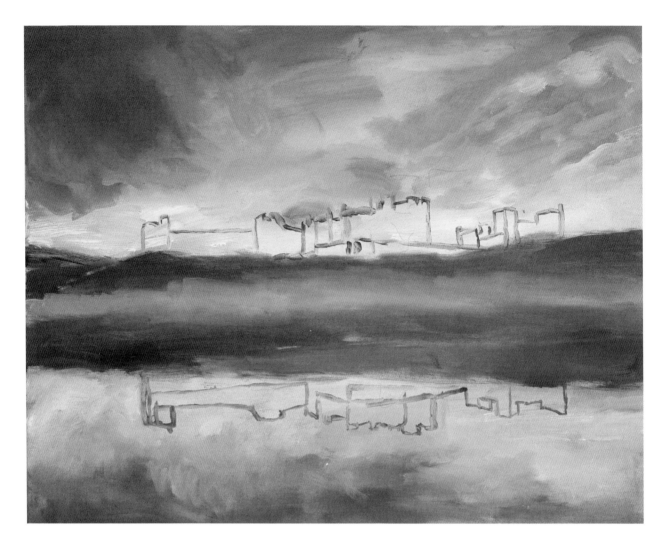

5 DRAW THE CASTLE OUTLINE

Next, draw in the outline of the castle and its reflection using a fine brush and a darkish colour. I found it helpful to draw over the outline of the castle in pen on the acetate so that I could see it clearly as a line. Obviously, this would not be possible if you were working from real life but this is one of the advantages of working from photographs. If you have time, I would advise leaving the painting to dry for a couple of days at this stage before moving onto the next stage.

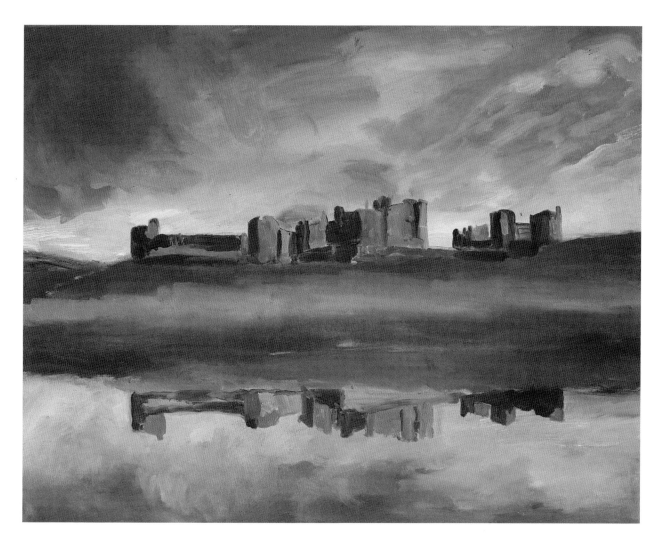

6 FILL IN AND SHADE THE CASTLE

Fill in the castle and its reflection with lights, mediums and darks. The evening sun makes parts of the castle look a warm-orange colour, yet the parts that are in shade look a dark brown-black. Mix some warm oranges and some dark browns and greys, and fill in the castle section by section. Blend where needed but maintain sharp contrasts of light and shade in other areas. Do not fill in surface detail at this stage: leave the painting to dry again for a day or so as this will make the next stage easier.

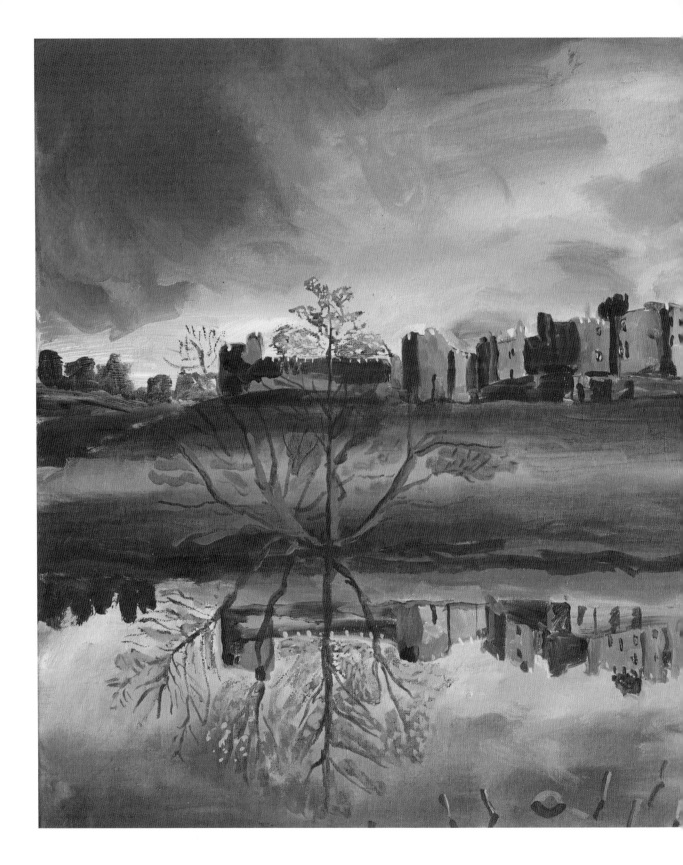

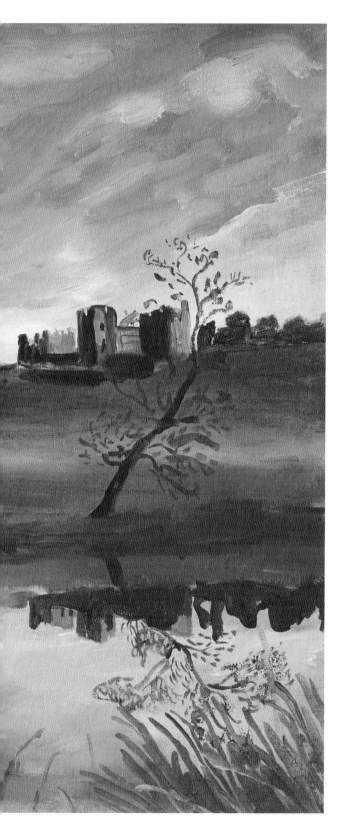

7 ADD SURFACE DETAIL

You are now at the stage where you can add the finishing detail of the turrets and windows to the castle with a fine brush, and also add the rushes in the foreground and the trees. Pay just as much attention to the reflections.

I added the windows of the castle using black over the warm-orange parts. I also broke up the tops of the walls with little dots of light blue where the sky is visible through the crenulations (the notched battlements).

For the trees, mix up dark, medium and light browns and paint in each trunk first with the medium tone, followed by the branches. Notice that the left side of the trunk and branches of the large tree on the left is in shadow and the other side is catching the light. Add the shadow with a strip of dark brown over the top of the medium brown.

To add the bare twigs, mix a thin dark brown and dab it over the sky in between the branches in dots and dashes using the end of the brush. If needed, you can break this up with small dots of blue layered over the top.

For the rushes, mix some light, dark and medium greens and paint them on individually with a fine brush. Notice that their reflections are darker than the rushes themselves.

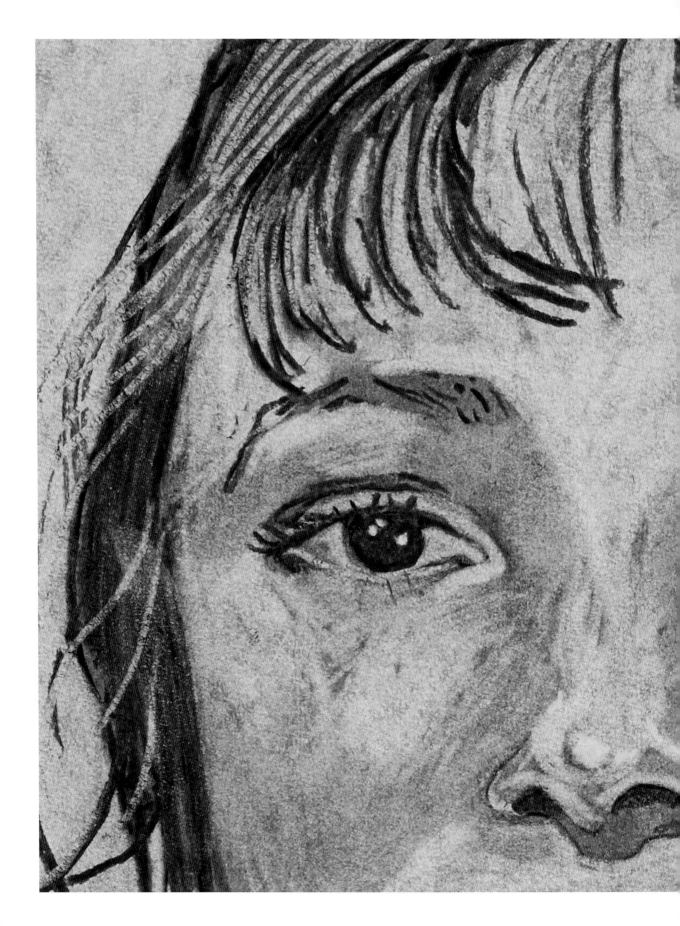

PORTRAITS

Portraits

The majority of portrait painters work from a combination of sketches of the sitter done from life and photographs taken during sittings. Facial features are fairly small so being able to achieve a realistic likeness depends on great accuracy both in the depiction of individual features and the relationships between them. This can be time consuming so it is fairly unusual for professional portrait painters to work without photographs.

However, there is a vibrancy that comes from drawing directly from a subject in real time, and this can be lost when working from photographs. You may decide to compromise accuracy for the sake of what you gain in vitality.

The decision to work from real life or from photographs may be led by the kind of look that you are hoping to achieve, i.e. hyper-realistic or more impressionistic, or simply by the amount of time you are able to have with the sitter.

Whether you are working from photographs or from real life, there a couple of things that you need to consider when starting out.

ANGLE

When starting any portrait it is important to get a firm grasp on the angle of the subject's head. Are you looking at them from straight on, are you seeing them in profile or do you have a three-quarter view of their face, i.e. you see more of one side of the face than the other? Also consider whether you are looking up at them from underneath, even if only slightly, or whether you are looking down on them.

There are a couple of key indicators of the face being at a slight angle to you: Can you see one ear and not the other? Is the distance between the outer edge of the eye and the edge of the face the same size on both sides of the face? If someone is facing you completely straight on this distance is the same on either side; if they are at an angle one side looks bigger.

PROPORTION

When it comes to proportion and planning the features of a face, it is useful to work out a couple of key marker points. For example, you could establish the halfway point between the very top of the head (including the hair) and the bottom of the chin, and also pinpoint the widest points on either side of the face. This is often the cheekbones but you should check.

Don't assume that both eyes are on exactly the same level: use your pencil as a straight line to help you to see if they are even, and do the same for the eyebrows and the ears. Also, don't assume that the mouth is horizontal and symmetrical – it could well be at an angle.

Use imaginary vertical and horizontal lines to help you work out the spatial relationships between features.

For example, if you imagine a vertical line straight down from the inside of one eye, you can see how it relates to the position of the mouth.

Always think about relative distances, sizes and heights. Is one lip bigger than the other? How does the distance between the top of the upper lip and the nose relate to the distance between the bottom of the lower lip and the end of the chin – are they the same or is one bigger than the other?

THE MAIN SHADOWS OF THE FACE

When drawing a face, it can be helpful right from the outset to get a really good grasp of the positioning of the main shadows. Remember that squinting your eyes can help to improve the contrast and make shadows a little easier to see. Examine whether one side of the face is more in shadow than the other or if there is very strong light from a particular direction. Light tends to come from above so anything that protrudes, such as the nose, brow bones, bottom lip and chin, is likely to have a shadow underneath it. Rather than thinking about line first and then tone, which is a good sequence for still lifes, think about shadows in conjunction with line right from the very beginning of your portrait.

KEEP IN MIND …

Part of our social development as humans means that we are extremely good at recognizing each other. This is why the skills below are important, as there are specific elements to consider when drawing or painting each feature to make them as accurate as possible:

Eyes

► Are the eyes hooded or in deep sockets?
► If they are in deep sockets, light often catches the top lid above the circle of the eye.
► You never see the whole circle of the iris as it is always cropped by the eyelids. How much of it is visible?
► Look carefully at the white shapes on either side of the circle of the iris.
► Eyebrows are not usually symmetrical – one is often higher than the other and they can be at slightly different angles. Where is the peak of each arch (they are often subtly different)?
► Which is higher: the inside or the outside of the eye? Don't assume they are the same height, i.e. that the eye is perfectly horizontal.
► Don't draw the eyelashes straightaway: examine the tone of the different areas of the eyelid and around the eye, and get these areas right before adding detail towards the end.
► Eyes are often about an eye-width apart, from front on.
► Making eyes further apart than they are in reality can help to make the person look happy, warm and attractive. Making the distance between the eyes too small can make a face look sterner.

Nose

► Do you see the nostril holes or just shadows – are you looking up at the subject or straight on?
► From front on, the tip of the nose overhangs the bottom of the nostrils – it is not on the same level – so there can appear to be a flattened upside down 'v' on the end of the nose (see illustration on page 166).
► Is the nose ridged or straight? Wide or thin? If it is ridged, which line is curved and how far along the nose is the ridge situated?
► The nose is often lightest along the ridge or on one side of the ridge. Thus, while the bottom of the nose can be drawn with a line, the main part of the nose can only really be depicted with shading. The sides of a nose are almost never depicted by sharp lines as the sides blend smoothly into the cheeks.

Mouth

► Is it symmetrical around the centre?
► Is the top lip or bottom lip bigger?
► Which is darker: the top or bottom lip?
► Does the mouth seem wider on one side than the other?
► Are the corners angled up or down? They might be different on either side.
► Is there a general slope to the mouth?
► The 'v' in the middle of the top lip is unique to each person so really study it and get it right.

IDEAS FOR BEGINNERS

► Take a look at photographic or painted portraits to get to grips with the key indicators of angle as outlined on page 158. For example, is the viewer looking up or down, or completely straight on at the subject, and how can you tell?

► Look for the key shadows of the face in photos, in real life or even at yourself in the mirror. Can you see the shadow under the nose? Is one side of the face more in shadow than the other? Where are the other main shadows on the face?

► Have a go at drawing a face by only drawing the shadows (see page 102).

► To begin with you will probably find it more manageable to work from photographs if you want to create a realistic likeness.

IDEAS FOR THE MORE CONFIDENT

► Try a self-portrait working from your own face in the mirror rather than a photograph.

► Ask one of your friends or family to sit for you while you sketch them for half an hour or longer if possible.

► Try quickly sketching people you don't know – on public transport, for example – to see how much of a likeness you can get with only a limited amount of time.

Classical bust in coloured pencil

Estimated time: 15 minutes
Medium: pastel
Surface: paper
Difficulty rating: 2

You will need:
► coloured pencil, sketchpad or paper, masking tape and board

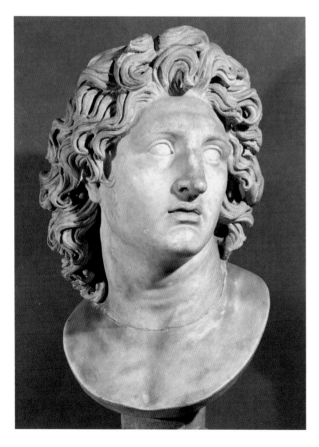

The aim of this project is to draw a classical bust in a continuous line without taking the end of the pencil off the paper. You can choose to work from life (in a museum, for instance) or from a photograph. Set yourself up so that you can comfortably see both the bust and your drawing at the same time.

1 START WITH THE FEATURES OF THE FACE AND WORK OUT FROM THERE

I suggest starting somewhere central like an eye or the nose. Think about the outlines of the eyes themselves and that you need to try and draw the brow bones too. Continue on from there to the nose. It's fine to loop back on yourself and wiggle around as much as you like. Try and be inventive and find interesting ways of describing three-dimensional form with just one line. For example, notice that I drew a circular tip on the end of the nose to help stop the nose from looking flat. Think in terms of contour lines and how you can use the line to describe the direction of the planes of the face.

2 BE MINDFUL OF SHADOWS

Just because you can't take your pencil off the paper doesn't mean that you can't shade, just scribble back and forth to create darkness where you need it. Remember that shadows usually appear under all the parts of the face that protrude, for example under the nose, under the lips and under the chin.

3 JUST KEEP DRAWING

Maintain one continuous line until the whole head starts to take shape. You can alter the weight of the line by pressing harder or softer to emphasize certain parts. The most important thing here is just to relax and have fun with it. It shouldn't take too long to complete so do a couple of versions if you feel like it and see how they vary. Work quickly, don't think too much and just keep moving the pencil. This is a good exercise to do with a time limit. Try giving yourself just 20 minutes to do the whole thing.

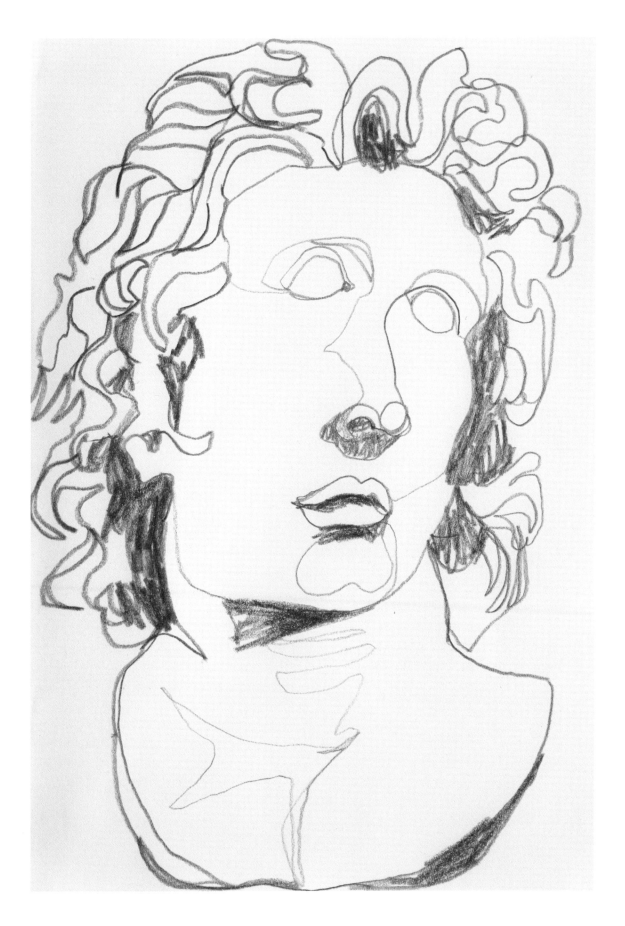

Close-up of nose

You will need:
- white paper, pastels, a cloth, masking tape, a stiff board
- *optional:* acetate, whiteboard pen

Estimated time: 40 minutes
Medium: pastel
Surface: white paper
Difficulty rating: 3

This project is all about working in extreme close-up to learn about the intricacies of skin tone and facial features.

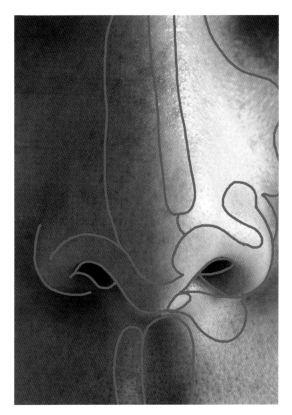

1 FIND THE DIFFERENT SECTIONS OF COLOUR

If you have acetate and a whiteboard pen, you can put the acetate over the photo and then draw lines on top of it to break it down into different areas of colour. This will help you to plan your drawing.

2 DRAW YOUR OUTLINE

Using pencil on white paper, draw the outline of the nose and the outline of the main areas of different colour. Then, using the side of a pink pastel, cover the whole sheet in a thin layer so that it has a slightly pinkish tinge. You can rub the pink pastel with a cloth if you would like to smooth out the marks.

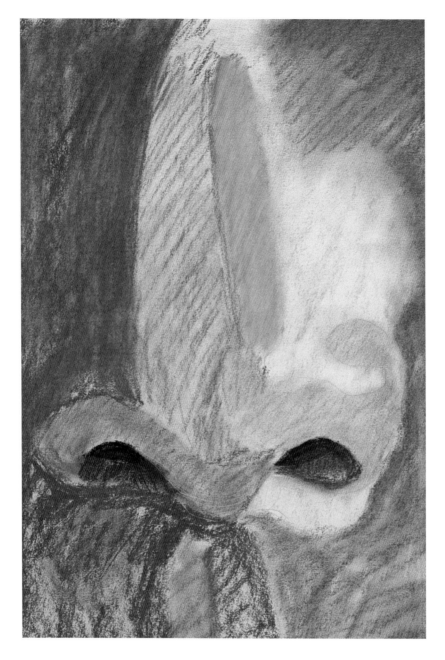

3 START COLOURING THE SECTIONS

Select a couple of browns, a black and an orange pastel, and roughly block in the different coloured areas. Leave the lightest areas empty so they just look very light pink. Always consider how one section relates to the next: should it be lighter or darker, redder or more orange?

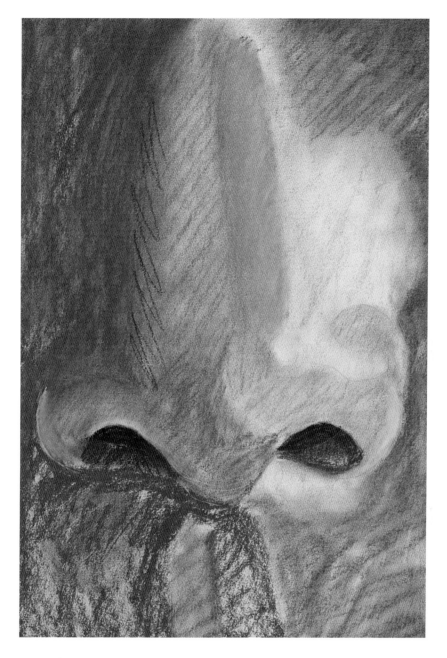

4 BLEND AND ADD MORE DETAIL

Smudge the sections of colour with the pads of your fingers so that they start to look smoother and blend into each other more seamlessly. However, make sure that you don't blend around the tops of the nostrils where there is sharp contrast between light and dark. The sharper you keep this contrast, the more realistic the nose will look.

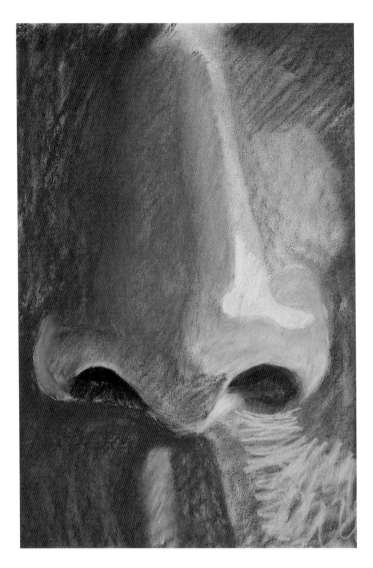

5 ADJUST THE TONE

Keep on looking back at the initial photo and adjusting the tone as required. For example, I decided that the bottom right of my drawing was a bit too dark so I went over it with a light pastel, and I lightened the left side of the septum as well. You can also see here that I have started to go over the light section on the right of the bridge of the nose with white.

6 ADD FINAL SURFACE DETAIL

Blend the sections where you have adjusted the tone and add any fine details. Look at the initial photo again and try to see if any of the sections have a particular colour tinge to them. Then make any final colour adjustments. For example, I added a little purple to the side of the right nostril and a little bit of gold to the light side of the bridge.

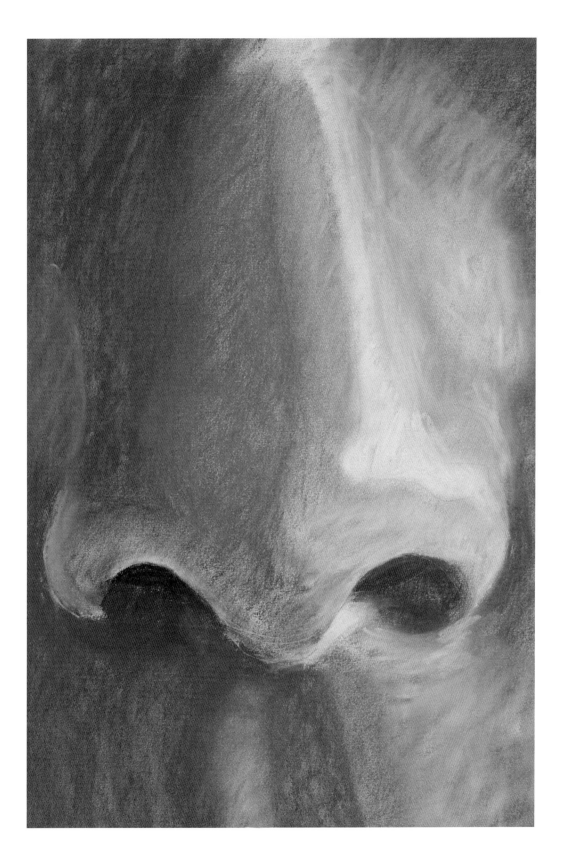

Family portrait

Estimated time: 5/6 hours
Medium: charcoal
Surface: mid-grey paper
Difficulty rating: 5

You will need:
▶ a family photograph, various sizes of charcoal, white paper, masking tape, board, a sharp retractable rubber
▶ *optional:* acetate, whiteboard pen

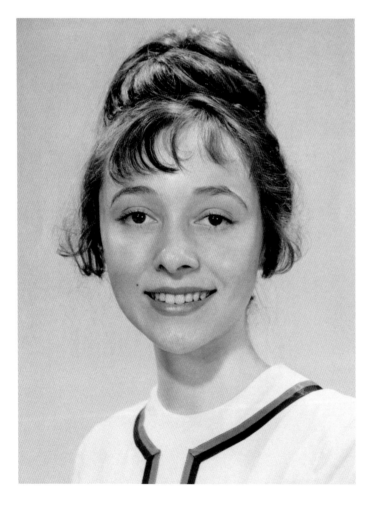

Here I have chosen a family portrait style photograph – you can use one of your own, or this one. This project is all about capturing likeness and character. Begin by preparing a mid-grey charcoal background (see page 38). Set up your materials and easel, if you have one (just work flat on a board if you don't), so that you can comfortably see both your chosen family photograph and your drawing at the same time.

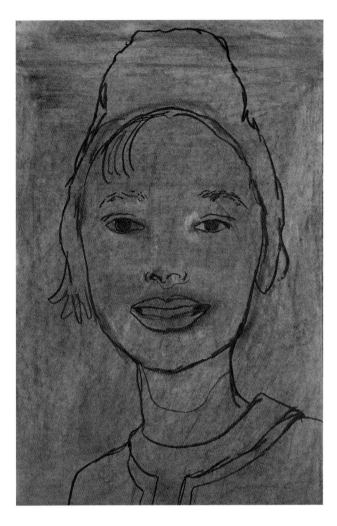

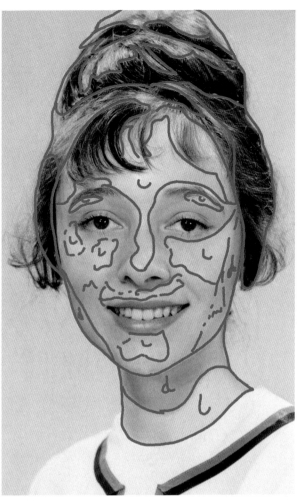

1 DRAW YOUR OUTLINE

Start sketching in the main features
(many people start with the eyes) and
outline of the face. Take care to get the size
of the spaces between the features correct.
Use imaginary vertical and horizontal
lines to help you (see pages 86–89).

Notice that the nose is only drawn
by outlining the shape of the nostrils;
the body of the nose is built up with
shading later on.

2 FIND THE AREAS OF LIGHT AND DARK

Work out where the main lights, darks
and mediums are on the face and neck.
If you have some acetate to place over the
photo, it can be helpful to draw around
the lightest areas in pen first, and then
mark up the darker areas.

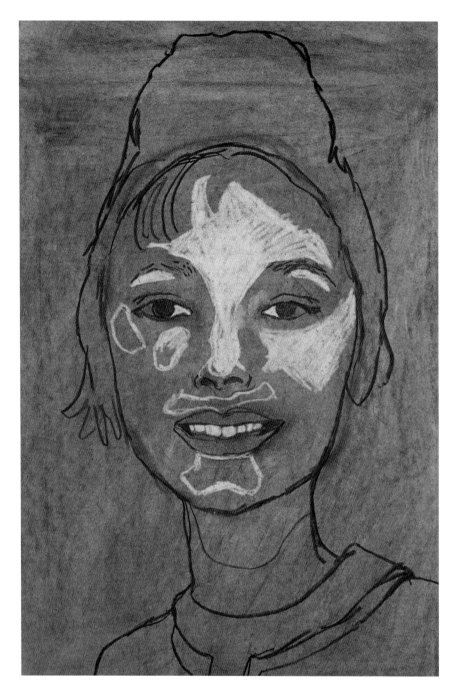

3 FILL IN THE LIGHT AREAS

Once you have noticed where the lightest
areas of the face are, you can draw around
the outlines of the light shapes with your
sharp rubber and then erase those
sections fully.

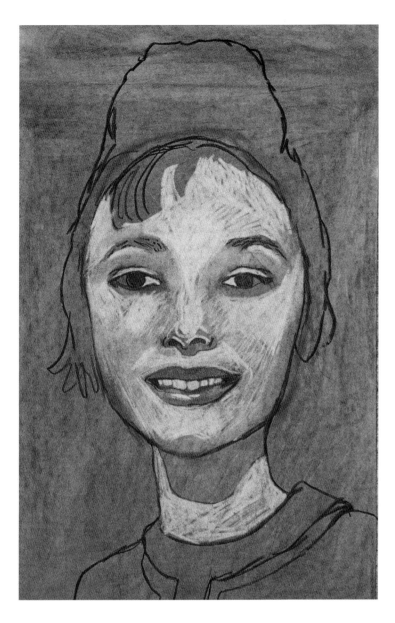

4 LIGHTEN AND BLEND THE DARKER AREAS

In order to stop the face from looking very patchy you also need to lighten the medium and dark sections by partially erasing them. Make sure that you leave them darker than the light sections by not erasing them fully. You can partially erase and then blend the medium and dark sections with your finger to get an even lightness in these areas. Add more charcoal if you lighten too much or erase more if they are still too dark.

Pay attention to whether there is a sharp tonal jump between sections of dark and light, as there is on the neck in the photo. The tones of other sections should be blended more gradually into one another, as on the cheeks.

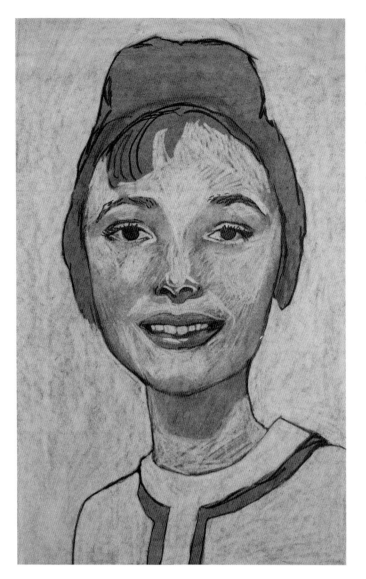

5 ERASE THE BACKGROUND

The next thing to do is to erase the clothing and background. The shirt is the lightest part of the photo, so try to get it as light as possible. Leave the rest of the background a little bit darker than the shirt but generally lighter than the face, if you can.

I also added detail to the eyes at this stage by erasing a light line across the bottom lids. I also added the eyelashes and detail to the socket crease. Make sure that you add eyelashes individually, and look carefully at the length and direction of each one.

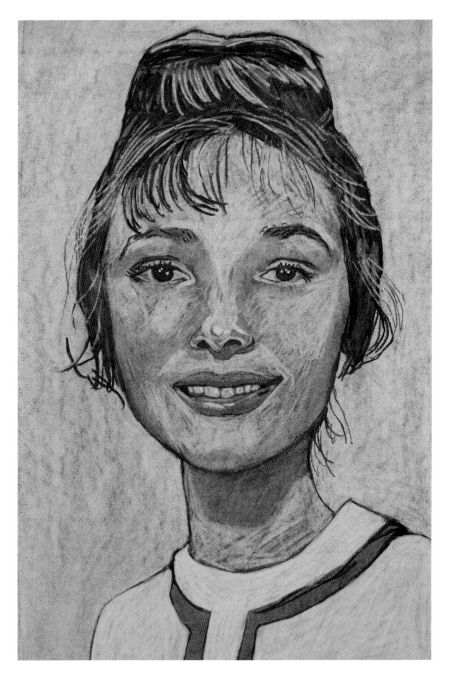

6 ADD DARKER DETAIL TO THE HAIR

Using a thin piece of charcoal, draw around and fill in the large dark shapes in the hair, such as the sides and the bun.

Then draw in individual dark strands that stand out to break up the edges of the shape of the hair at the sides. Start building up the fringe using charcoal strokes for individual strands.

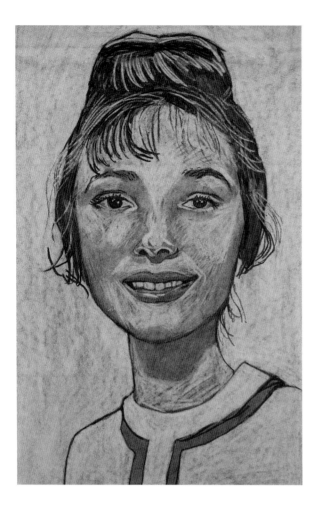

7 ADD LIGHTER DETAIL TO HAIR

Using the sharp corner of a stiff rubber, erase individual strands of light-looking hair over the top of the darks that you have added. Follow the direction of the strands of hair as much as possible.

I find the best rubber to use for this particular step is the small rubber on the end of a good-quality pencil. Pencil rubbers have a sharp edge and are stiff enough to give you good control.

You can also use the rubber to add definition to the face where needed, for example around the mouth, nose and eyes to refine their shapes. It is also time to add the dots of reflections in the eyes. This will really help to make the face look alive.

8 ADD FINAL DETAILS

If you have a white pastel pencil you can add definition and brighten the reflections in the eyes. You can also add reflections to the teeth and further whiten the shirt by filling in with the light pencil.

Also, don't forget to spray the finished picture with fixative soon after it's finished because charcoal can smudge very easily.

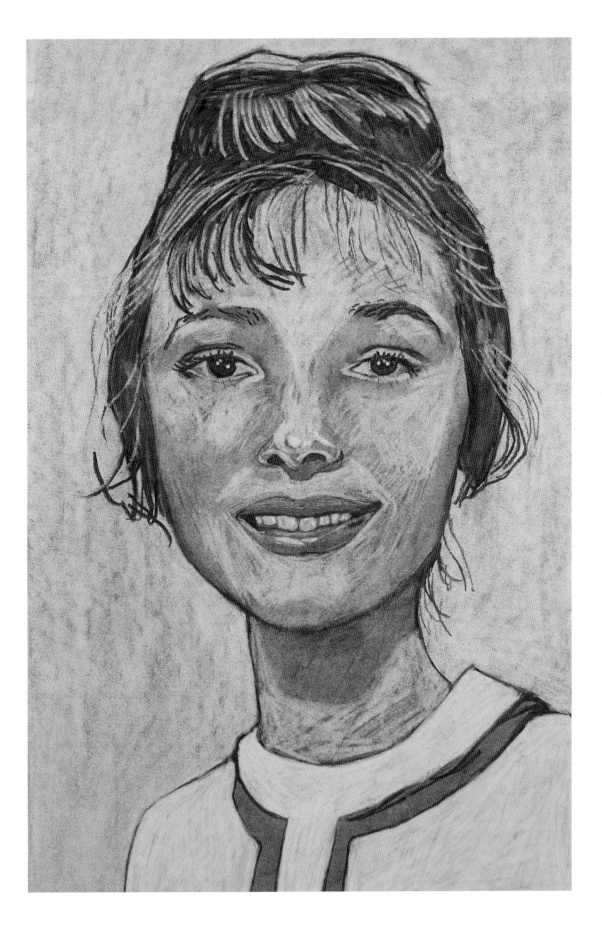

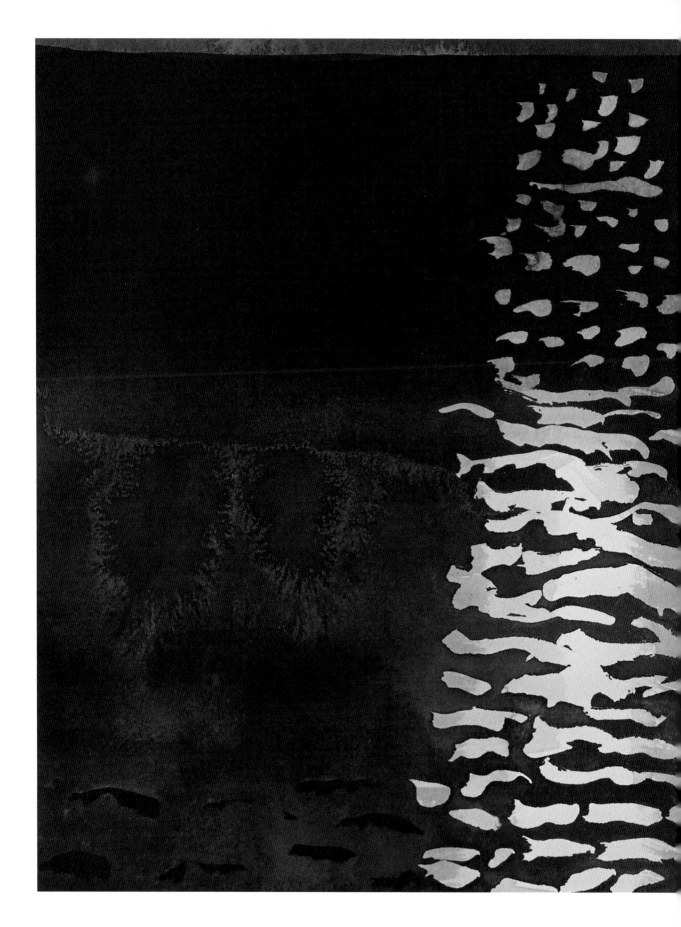

SEASCAPES

Seascapes

The sea is a constantly moving and reflecting body – a large meteorological mirror – which brings inspiration and challenges to the artist in equal measure. Drawing and painting the sea often involves finding a repeatable motif-like form or stroke to represent the individual waves and ripples. Ripples can be represented by individual horizontal brushstrokes of different colours or repeated triangular marks that capture the constant, sometimes subtle motion.

Seascapes tend to focus on three main aspects of the sea: its mystical, hypnotic nature when calm; its dramatic and destructive power when energized; and how man relates to it through boats, fishing and sailing for work and play. The latter provides plenty of opportunity for the introduction of colour and graphical shape through triangular and rectangular flags and sails.

As with landscapes, part of the task when depicting seascapes is creating the illusion of depth. This is mainly achieved through reducing scale so that ripples, waves and boats that are further away look smaller and are often less intensely coloured and clearly depicted.

Just like landscapes and cityscapes (and, indeed, still lifes and portraits), it is important to work out where the lights and darks are in the scene in order to depict depth and atmosphere. In the sea-at-night project in this chapter (see page 188), for example, it is important to note that the foreground trees are the darkest feature of the scene and that the sky is lighter than the sea at the horizon line. As you move down from the horizon towards the centre of the picture, the sea becomes a little lighter and then gets darker again towards the bottom.

IDEAS FOR BEGINNERS

- ► Take a look at the seascapes of Raoul Dufy, paying particular attention to his colour palette and the motif-like shapes he uses to depict the moving surface of the sea.
- ► Remember that the sea will reflect the sky and weather.
- ► When working from photographs, put a layer of acetate over the top and draw around the areas of light and dark with a pen to help you recognize and plan the different sections, including shadows and reflections.

IDEAS FOR THE MORE CONFIDENT

- ► Look at the sea and concentrate on the ripples and waves: can you see any particular repeated shapes? How would you break down the surface of the sea into shapes that you can recreate?
- ► Take a look at Tracey Emin's drawings of Margate and make your own attempt to draw the sea from memory.
- ► Sketch from life: go to the coast with a sketchbook and drawing materials and just start drawing.

Seaside coast scene

Estimated time: 30 minutes
Medium: coloured pencil
Surface: dark grey paper
Difficulty rating: 2

You will need:

► a stiff board, masking tape, a rectangle of dark grey paper about A4 size and colouring pencils including a white

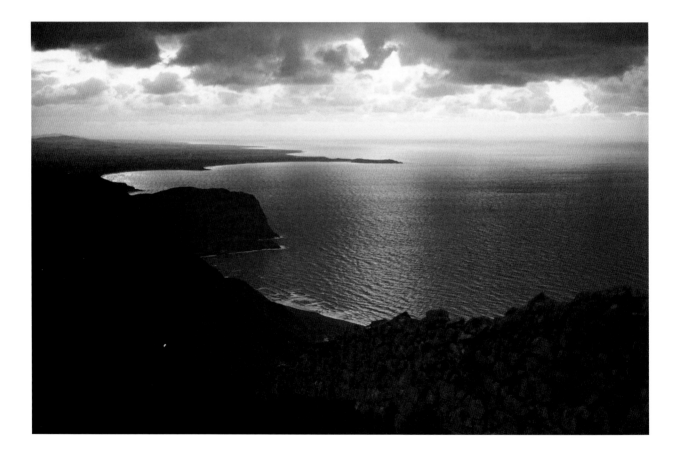

Your aim in this exercise is to create tonal contrast between the different areas of the image.

1 SKETCH YOUR OUTLINE

Tape the sheet of paper to the board using masking tape. Use a black colouring pencil to sketch in the outline of the dark swathe of rock in the foreground, and then sketch in the outlines of the other dark areas of outcrop. Fill in all these dark areas with the black pencil, being careful to make sure that the foreground is darker than the other areas.

2 ADD WHITE TO THE SKY AND SEA

Look at the initial photo with squinted eyes to help you see it tonally. Add white to all the areas that should be light.

3 ADD COLOUR AND FINISHING DETAIL

Add peach, purple and yellows over the areas of light. If necessary, darken the rock in the foreground further by adding another layer of black, especially at the upper edge to increase the contrast with the sea and the distant outcrops.

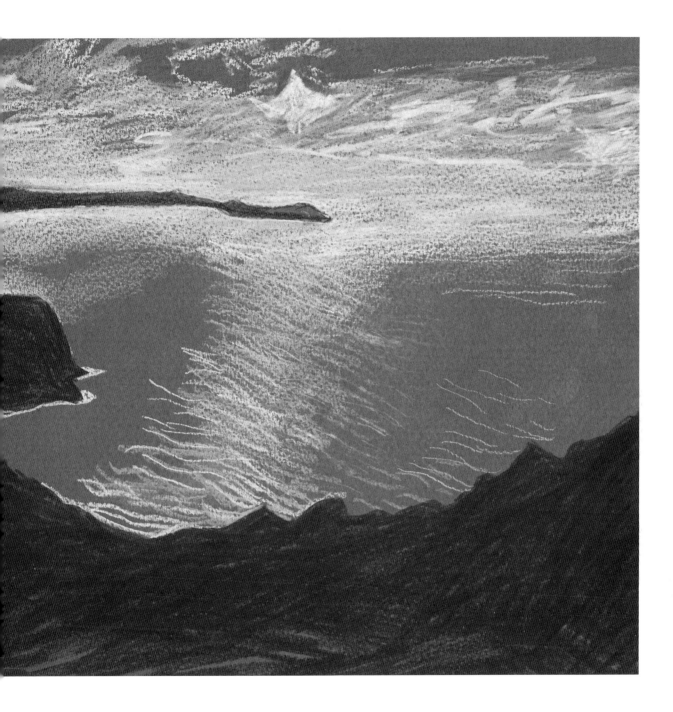

The sea at night

Estimated time: 1 day including drying time
Medium: permanent black ink
Surface: white watercolour paper
Difficulty rating: 4

You will need:

► a water-resistant stiff board, masking tape, an A2 sheet of white watercolour paper, masking fluid, an old small brush, permanent black ink, a wide brush, small, medium and large round-ended watercolour brushes, a pencil, small, shallow pots/trays or a compartmentalized palette, and scrap watercolour paper

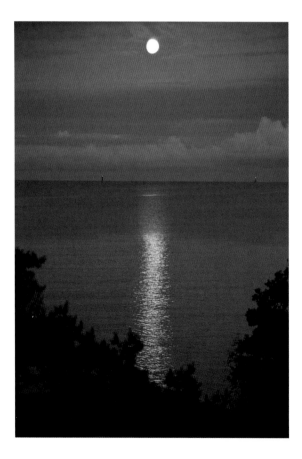

The focus here is on mark making, brushstrokes, layering, colour or the lack of it and, most importantly, atmosphere. Prepare your paper by sticking down all the edges onto a stiff board with masking tape. The masking tape will protect the edges of the paper from ink, leaving a clean white border when the work is finished and the tape is removed.

1 PAINT THE FOREGROUND

The first thing to do is paint in the dark trees in the foreground. I decided to do this in a fairly impressionistic way without any underdrawing. I used a large round-ended brush and undiluted ink in a freehand manner, building up the trees mark by mark to give a slightly broken-up effect. Leave to dry.

2 MARK IN THE HORIZON AND REFLECTIONS

Decant a little of the masking fluid into one of the trays or sections of the compartmentalized palette. Using the masking fluid and a small old brush that you don't mind ruining, paint in the round shape of the moon at the top. Next, mark in the line of the horizon with a pencil, and then start painting in the reflections of the moon on the water with masking fluid.

The important thing here is that the marks you make increase in size incrementally as you go down the paper so that the ripples of reflection look larger the nearer they are. I placed dots of masking fluid just near the horizon that gradually grew into vaguely horizontal dashes as I went further down the paper. Leave to dry.

3 ADD RIPPLES TO THE FOREGROUND

Next, taking your small watercolour brush and some undiluted ink, add some small, dark, horizontal ripple marks in the foreground and leave to dry.

4 DIVIDE THE SEA INTO TWO HORIZONTAL SECTIONS

Take your widest brush and dampen the surface of the paper up to the horizon line, but not above it. Brush on enough water so that the whole surface is damp, but it shouldn't be dripping or pooling with water.

Next, make two dilutions of the ink, adding water and testing them on the scrap paper to check the tones. One dilution should be just lighter than the undiluted ink and the other should be lighter still.

Use your widest brush to paint the darker dilution across the paper in a line just below the horizon. Fill in the rest of the sea with the slightly lighter dilution. The two areas should blend into each other easily because you have wet the paper first. You are trying to create a fading effect from the horizon down.

Leave the painting to dry. This is very important because we are looking for a clean edge at the horizon: if you paint the sky in before the top section of the sea is dry, the sky and sea will blend.

5 PAINT IN THE SKY

Mix up a dilution that is slightly lighter than the lightest shade that you used on the sea. Use your wide brush to cover the sky with it.

Next, working while the sky is still damp, use your medium-sized watercolour brush to add a couple of horizontal strokes of the darker shade that you used for the top of the sea. These strokes should be roughly at the top and in the middle of the sky as you need the sky to be lighter than the sea at the horizon. The strokes should bleed into one another and hopefully look like billowing clouds. Leave to dry.

6 REMOVE THE MASKING FLUID AND TAPE

When the painting is completely dry you can peel away the masking fluid to reveal the white paper underneath. If you find that the moon and reflections on the water look a little too bright, you can temper them down with a highly diluted ink wash over the top. Finally, peel off the masking tape from around the edges to reveal the pristine white border.

Sailing boat

Estimated time: 5/6 hours
Medium: acrylics
Surface: white paper
Difficulty rating: 5

You will need:

▶ paper, a stiff board, a pencil, a rubber, masking tape, acrylic paints (phthalo blue, cerulean blue, ultramarine blue, cadmium red, crimson, cadmium yellow, lemon yellow and white), a stay-wet palette, small, medium and large round-ended brushes, a very fine pointed brush, a pot of water and a tissue or rag

▶ *optional:* a sheet of acetate, a whiteboard pen and an easel

The aim of this project is to combine the graphical shapes of the boat and sails with the natural movement of the waves.

1 DRAW YOUR OUTLINE

Looking closely at the sailing boat, draw the outlines and horizon in pencil. As usual, you don't need to draw much of the surface detail at this stage; features such as ropes will be added at the end. However, it can be helpful to draw around the main lights and darks at this stage, for example the darker section at the bottom of the hull of the boat. Do not set up your acrylic palette until you have finished the drawing.

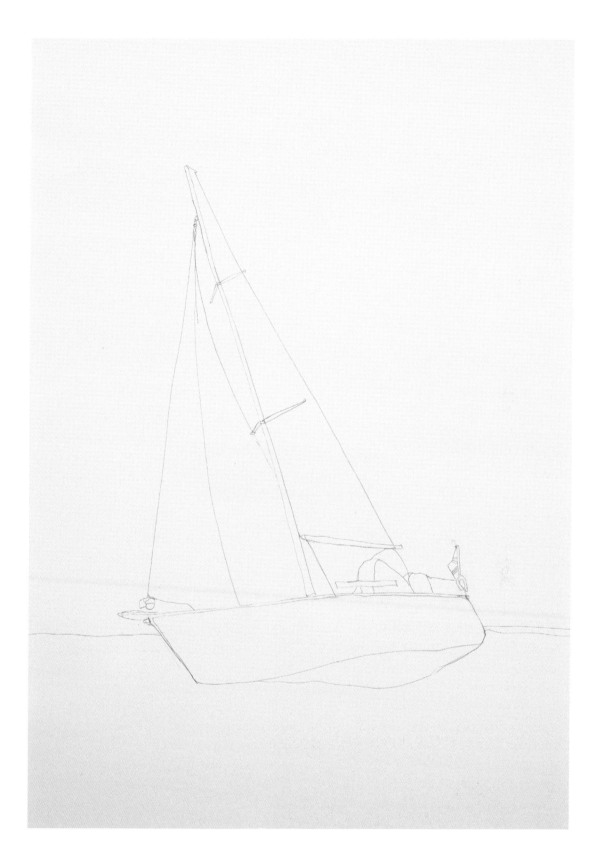

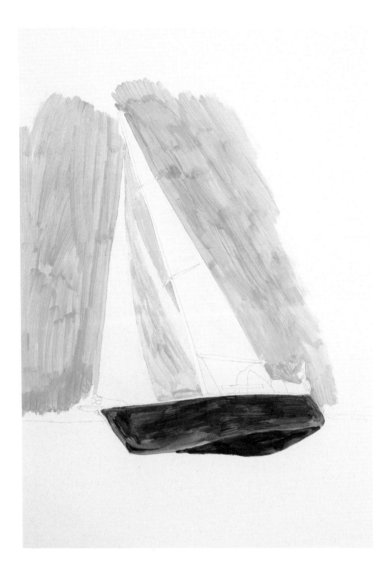

2 BLOCK IN THE MAIN COLOURS

Start filling in the colours of the large, individual areas: the sails, the sky and the body of the boat. Your underpainting can be fairly rough as most of it will get painted over by the end anyway. I used a cerulean-blue base for the sky and two shades of phthalo blue for the hull of the boat. For the sails, even though they look fairly white, I painted them a very pale blue-grey. It's very unusual to use pure, undiluted white as a colour as most things have a slight tint or darkness to them. If you are struggling to tell what you need to add to white to get a particular shade of off-white, hold up a sheet of white paper next to the off-white area. This will help you see whether the off-white is, for instance, more blue, more pink or more grey than the pure white, thereby indicating what colour you need to add to the white paint.

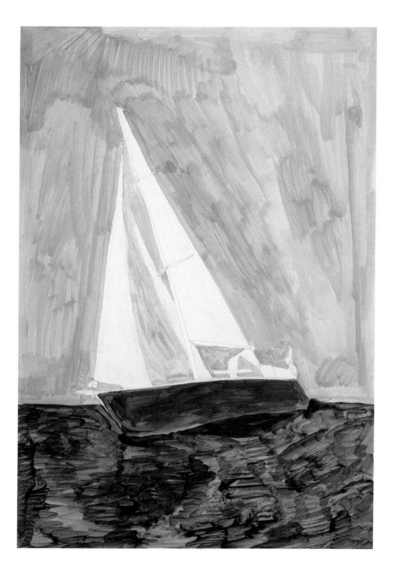

3 FILL IN BACKGROUND

When you have finished blocking in the sky, mix a darker blue, using either ultramarine or phthalo as the base, and fill in the sea roughly with a medium-size brush. Notice how I have deliberately left the sea and sky fairly textured at this stage. I used generally horizontal brushstrokes for the sea. Where my brushstrokes have overlapped, there is variation in the darkness of the colour, helping to begin to suggest the broken-up surface of the sea.

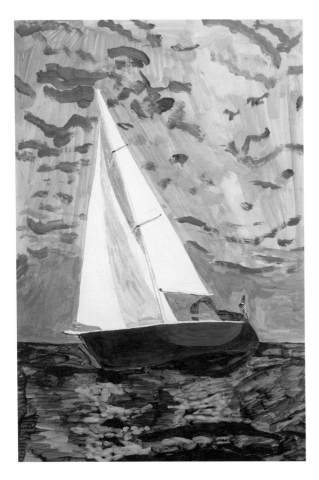

the dark areas with solid colour. I filled in the light bits of foam with separate dabs of paint, leaving small spaces between them to simulate the broken-up texture.

Next, using a fairly thick brush and a darker blue, I started to build up the wispy marks in the sky that represent the gaps between the clouds. I also felt that I needed to make the bottom of the sky darker so I added a layer of darker blue up to the level of the clouds.

5 FILL IN CLOUDS AND ADD FINAL DETAIL

Mix a few shades of very light grey for the clouds. Using a thick brush, layer these fairly thinly over the sky in wavy strokes to simulate the clouds.

Continue breaking up the surface of the sea by adding more dabs of lighter colour for the foam and more of the dark blue in areas that look dark.

Using a very thin brush, add the final detail to the boat, such as the railings at the side and the detail on the masts. I decided to use pencil to draw some of the ropes that looked dark grey because they were so thin. It's much easier to make a long, thin line with a sharp pencil than it is with a brush.

Finally, again using a small brush and some of the light colour you used for the foam, create the spray. Do this by dabbing some small but uneven-sized strokes and dots on the front of the boat.

4 ADD DETAIL

Detail can be added in two ways: by layering paint on top of paint that is already there; or, for small details, by using a thin brush in the areas that have not yet been painted.

I find it helpful to draw around different areas of light and dark with a pencil on top of the paint that is already there, as long as it's dry. This can help you plan the shading.

I drew around the semi-circular area of lighter blue on the side of the boat and then had a look for the main areas of shadow cast by the boat on the sea. Notice the shadow just below and in front of the boat.

I then drew around the other main areas of dark and light on the sea, and filled in

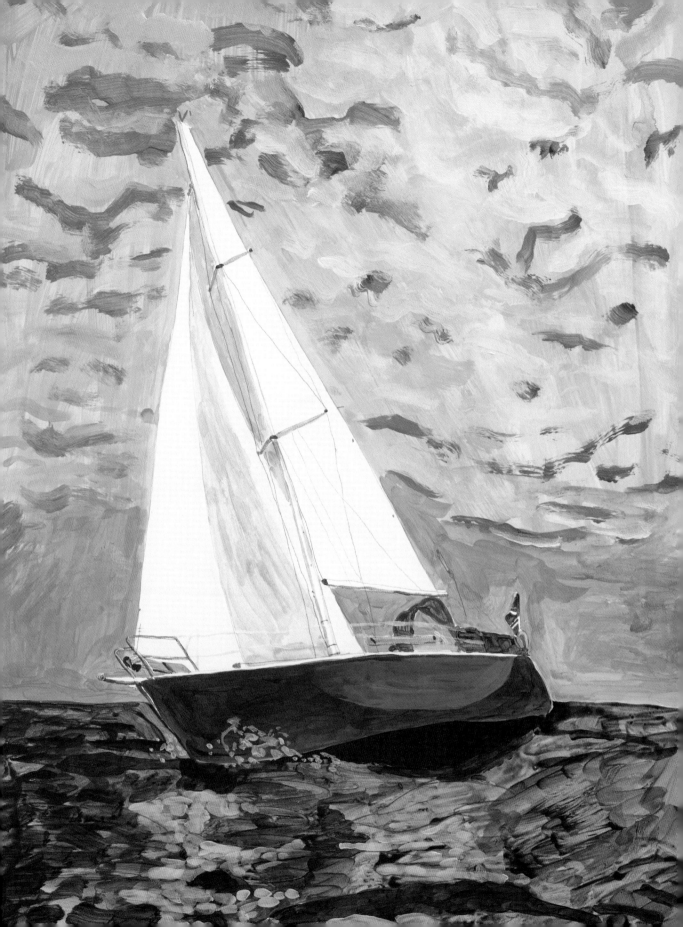

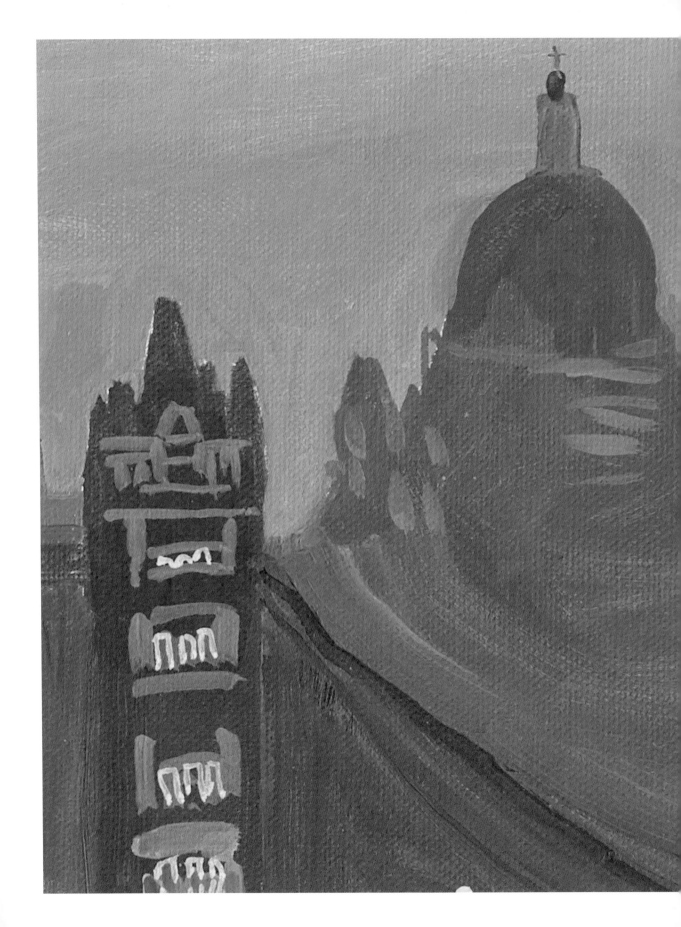

CITYSCAPES

Cityscapes

Cities are made up of people, buildings and transport systems, and provide such diversity and variety that there are rich pickings to inspire visual art.

A typical cityscape shows a fairly wide view of a large part of a city. To do this you need a good vantage point and usually somewhere that is fairly high up so that you can see for a decent distance. However, a vantage point by a river can sometimes allow a long view that isn't blocked by tall buildings.

Traditional cityscapes often include recognizable landmarks or famous buildings that make the city distinctive. For example, the main project in this chapter involves depicting Tower Bridge in London. However, cities are much more than just tourist picture postcards and it can be interesting to think about how to depict a city in an unusual or less traditional way. You may choose to focus on an unconventional or unglamorous aspect that nevertheless reflects the spirit of the city and the day-to-day life of its inhabitants. Frank Auerbach, one of the UK's best-known painters and a long-time resident of London, often depicted the city through its building sites. Go out into the city with an open mind and see what catches your eye.

Think about the time of day to go out – consider catching the city in the morning light or at dusk. The harsh midday light can make long views look a little flat but can be advantageous if you wish to capture more detail. Don't discount the night-time either. Many cities come alive at night and the electric lights of cars, lampposts, advertising hoardings and windows can provide an exciting and atmospheric view of modern urban life.

Stone archway in white pencil

Estimated time: 1 hour
Medium: white pencil
Surface: midtone/dark coloured paper
Difficulty rating: 3

You will need:

► a sheet of mid-to-dark coloured paper, a stiff board, masking tape, a white pencil and a pencil sharpener.

Your challenge here is to draw the arch using only a white pencil. You need contrast so use a mid-to-dark coloured paper – I used ultramarine. Tape the paper to the board all around the edges.

2 ADD SHADING

Use the pastel to fill in the areas
that should be dark and add stripes
to the textured parts.

3 ADD WATER TO SHADED AREAS

Using a water-brush or just a paintbrush
and a pot of water, add water to the shaded
areas. Use the colour that is left on the brush
to add medium tones where needed.

Architectural scroll

Estimated time: 30 minutes
Medium: water-soluble pastel
Surface: white paper
Difficulty rating: 2

You will need:
▶ an A3 sketchbook or sheet of white paper, water-soluble pastels, a water-brush or paintbrush and a pot of water

This is a fairly short exercise to practise describing architectural detail, rather than an exercise in precise draughtsmanship.

1 DRAW YOUR OUTLINE

Just draw straight onto the paper with coloured water-soluble pastel. You won't be able to erase mistakes but just go for it. Don't worry if it looks a bit sketchy – it doesn't have to be perfect.

IDEAS FOR BEGINNERS

► Focus on close-ups: go out with a sketchbook and depict interesting architectural details such as the windows of churches or the moulding or carvings on the side of buildings.

► Take photos of details and work from those back at home.

► Try working on medium-tone paper with both light and dark pencils; use the light pencil to pick out where the sun catches on certain features and the dark pencils to block in the shadows.

► Draw in a medium that you haven't tried before, such as water-soluble pastels (see page 44).

IDEAS FOR THE MORE CONFIDENT

► Look up at tall buildings from ground level and see if you can capture that view and sense of immenseness in your sketchbook.

► Find an unconventional way of depicting the city – get up high and capture the paraphernalia of rooftops such as satellite dishes and air-conditioning systems.

► Try drawing without lines, using just shading and highlights on dark paper (see page 102).

► Draw from further away, taking in wider views.

1 FILL IN LIGHT BLOCKS

Start drawing the lightest blocks of the arch with white pencil and filling them in as you go along. The aim of this exercise is to think about tone, instead of line, from the outset, so just draw all the lights and try to think in terms of shapes instead of lines as much as you can.

2 CONTINUE ADDING LIGHT BLOCKS AND SOME SHADING

Follow the shape of the main arch, drawing the light blocks that make up its structure. Draw in the shadow that falls in the archway. Think about the texture of your pencil marks and how they relate to the quality of the stone.

3 ADD MORE SHAPE AND BEGIN HATCHING

Fill in the rest of the frame of the main
archway and fill in the details of the area
above. Fill in the basic shapes of the
adjacent arch. Begin to fill the medium
areas with hatching (shading lines that all
go in the same direction).

4 FINISH WITH COMPLETED HATCHING

Add detail to the adjacent arch. Finish
hatching the medium areas and remember
to change the direction of the lines for the
different planes. Leave the darkest areas
blank and don't forget to add hatching to
the ground to aid depth.

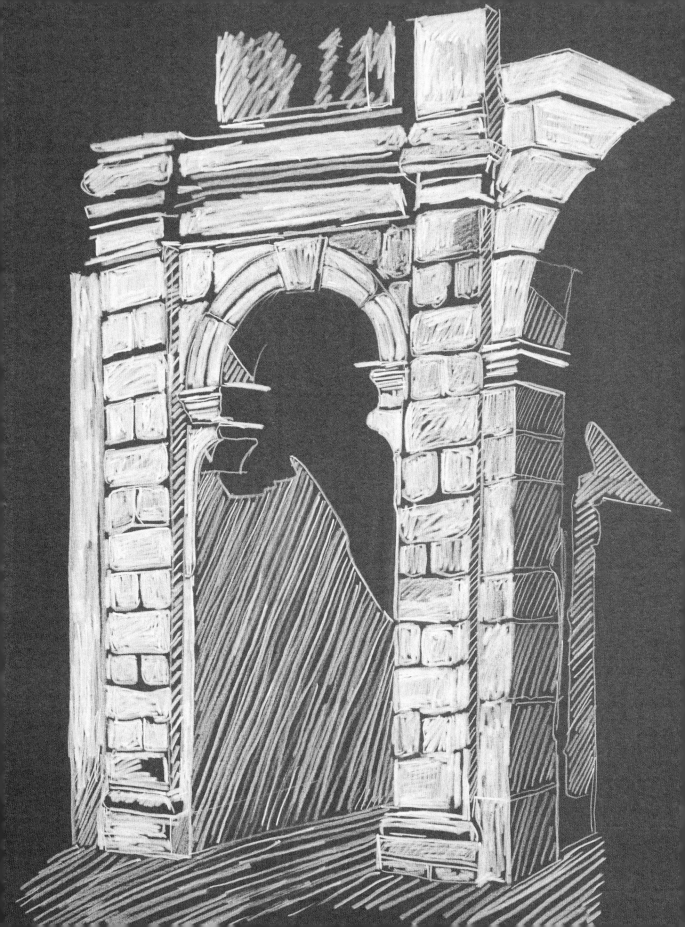

Tower Bridge at dusk

Estimated time: 2–3 days including drying time
Medium: oil paint
Surface: a white primed canvas roughly A2 size
Difficulty rating: 5

You will need:

▶ a pencil, small, medium and large round-ended, stiff-bristled brushes, a very small pointed, soft-bristled brush, oil-painting medium in a closable jar, a rag, an oil-painting palette, oil paint in ultramarine, cerulean blue, alizarin crimson, cadmium red, cadmium yellow, lemon yellow and white

▶ *optional:* acetate, a whiteboard pen and an easel

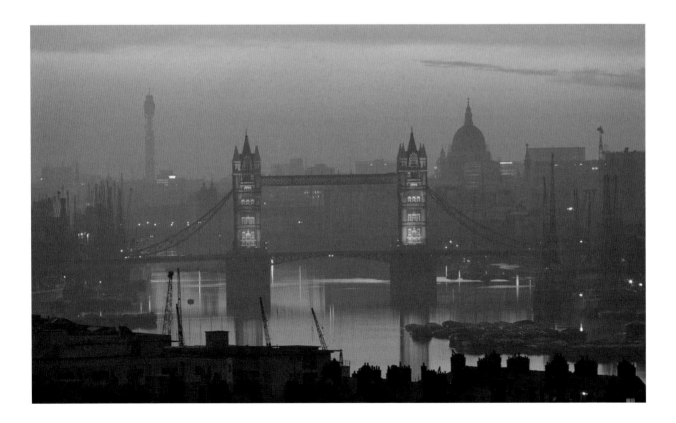

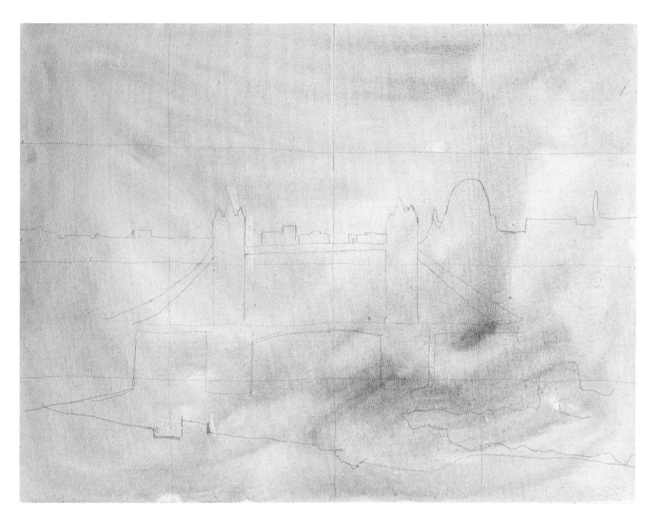

The idea of this project is to learn to create depth and also depict detail in wide-view landscapes.

1 PREPARE YOUR CANVAS, DRAW YOUR OUTLINE

Set up your oil-painting palette with the colours in the order described above from ultramarine to white, left to right.

With your large brush and quite a lot of oil-painting medium, mix up thin colours on your palette. Paint them onto the white canvas in a rough way so that the whole surface is covered in a multicoloured wash. Leave to dry overnight.

Next, draw in the outlines of all the main areas (the bridge, the horizon and the dark block in the foreground) in pencil on top of the wash of colour. To help me do this I laid a sheet of acetate over the initial photograph, drew a grid on it and drew the main outlines over the top with a whiteboard pen. I then drew a corresponding grid onto the canvas itself and, square by square, copied the outlines from the initial photo (see page 99 for more on this technique). If you do not have acetate, you can draw the lines in freehand.

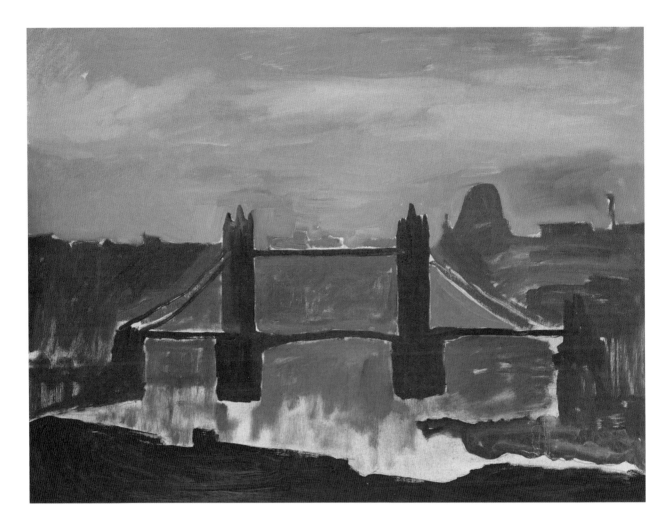

2 BLOCK IN YOUR MAIN COLOURS

Start blocking in the colours of the main
areas but don't worry about it looking
fairly rough at this stage. Notice that
the bridge is a darker blue than the
background around it and that the
foreground is the darkest area.

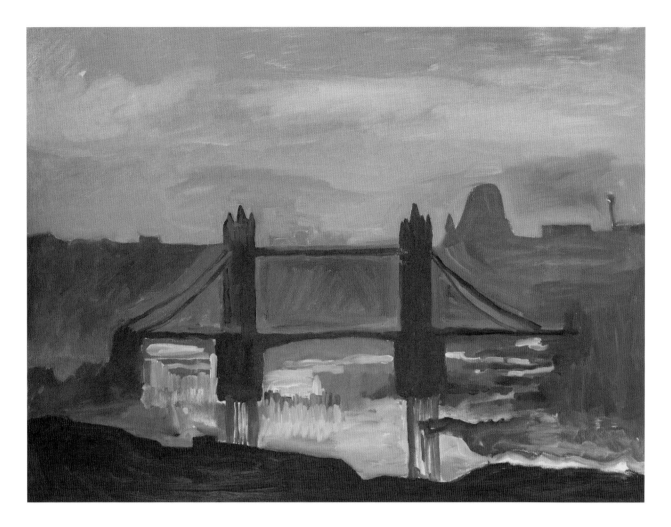

3 REFINE YOUR UNDERPAINTING

Start to tidy up the underpainting using
a small brush to fill in gaps between
sections. Add the largest of the reflections
to the water, including the dark reflections
of the bridge and some of the largest light
horizontal reflections.

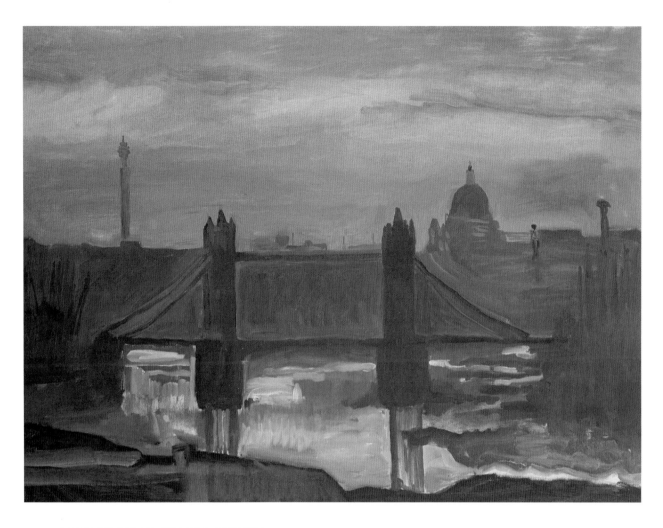

4 ADD DETAIL TO SKY AND SKYLINE

At this stage, I felt like the sky needed
a little reworking so I blended it with
a clean, medium-size brush dipped in
oil-painting medium and added the wispy
cloud on the right. Then I added detail to
the skyline and tidied up the domed shape
of St Paul's Cathedral with my tiny pointed
brush. I mixed a dark blue colour and,
again using the tiny pointed brush, added
the cranes in the dark areas to the far left
and right of the bridge.

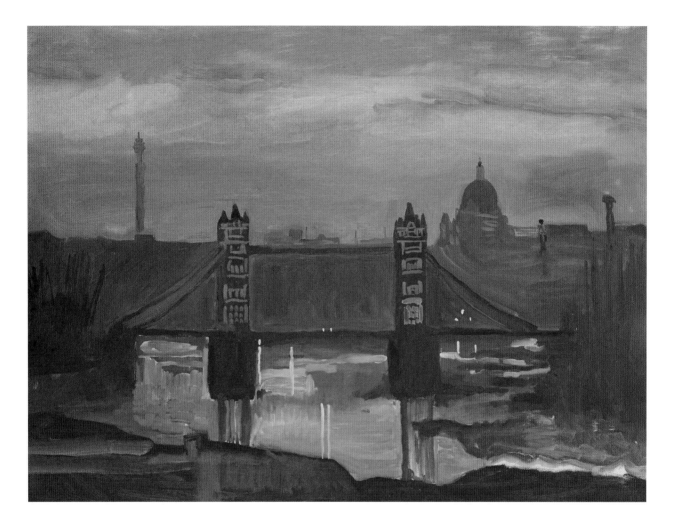

5 ADD SURFACE DETAIL

Mix a light blue for the illuminated sections on the bridge and, using the thin brush, paint them on according to the pattern of the architecture. You can also start to add the lights in the background and on the river as dots and vertical streaks of white, off-white and red.

6 ADD FINAL DETAIL

(See next page.) Continue adding fine detail by putting some very thin white highlights on the towers of the bridge. Add the pinpoint lights, wherever you can see them, as tiny dots. Then, finally, add the chimneys and tiny, spindly cranes in the foreground.

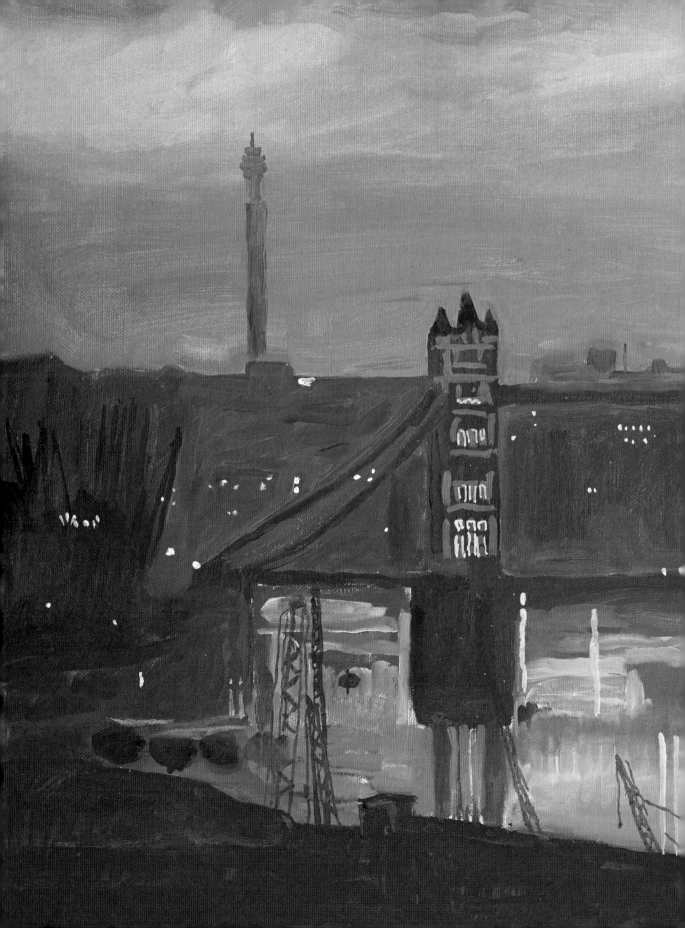

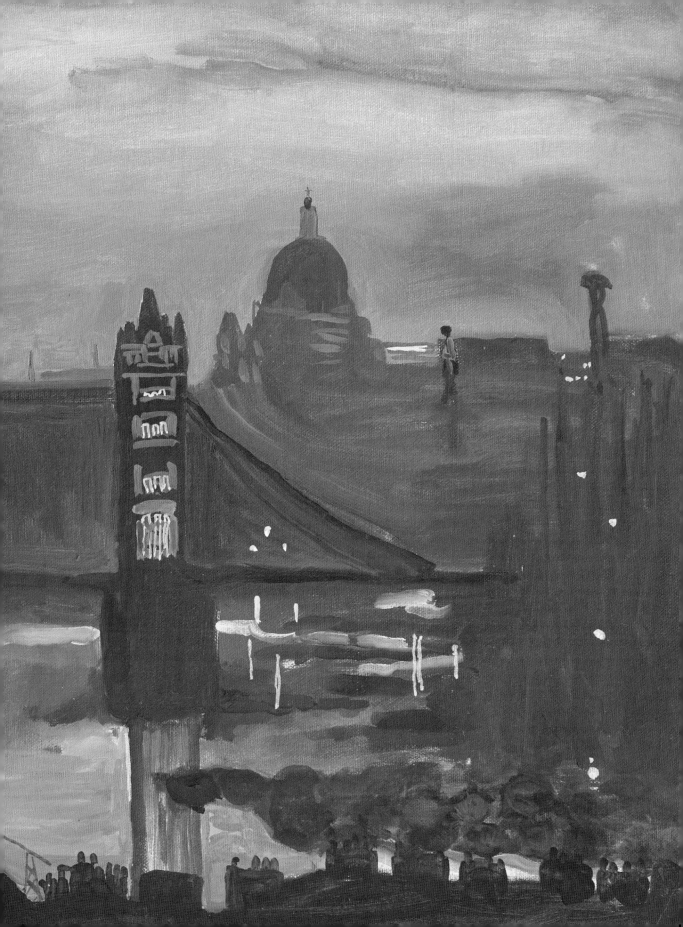

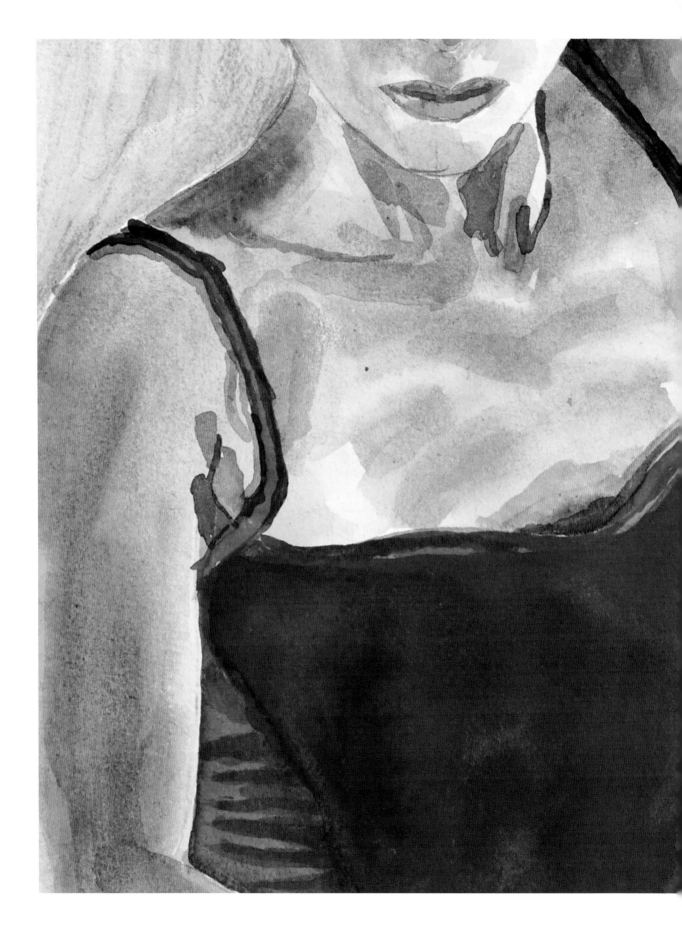

HUMAN FORM

Human Form and Movement

To represent the human figure in action you often need to go against your brain's natural tendency to want to draw the human figure as symmetrical. The human form is only symmetrical when you look at it straight on, it is standing upright and not performing any kind of action.

There is a great tradition of artists representing dancers, acrobats, performers and sportsmen and women in all manner of energetic and dynamic poses. When representing the human figure in actions like these, the works often become about the energy, vitality and exuberance of human life. The lack of symmetry in these works, for instance when a dancer's arm is stretched out, is obvious but it is also present when a figure moves into action of any kind, however undramatic. Pairs of limbs and joints that you assume to be symmetrical tend to get out of alignment and one inevitably looks higher than the other. Imagine, for example, when someone has all their weight resting on one leg: the hip of the weight-bearing leg is inevitably higher up than the other hip and the knees are probably at slightly different heights too.

When the figure is in dynamic action, it can be important to work quite quickly. In life-drawing classes the model often holds a dynamic series of poses, often involving a stretch or twist, for a short amount of time so the artists have to catch what is sometimes called 'the spirit of the pose' with some level of spontaneity. You have to edit out all inessential details and labour in order to work quickly – this is sometimes referred to as 'abbreviation'.

Often, the result from working in this way is that you loosen up a little and start responding more instinctively to what you see. The resultant simple sketches can become a celebration of movement, physicality and immediacy. The drawings can be simple line drawings without any tonal information or they can be tonal without any lines at all.

Most people begin drawing the figure in action by going to a life-drawing class, but another idea is to draw classical sculptures. The statues in museums and galleries are often in very dramatic positions that no life model could hold for very long, enabling the artist-in-training to practise drawing the figure in action with greater leisure.

IDEAS FOR BEGINNERS

- Look at Henri Matisse's drawings and cut-outs of dancers and acrobats in action, and note the flowing lines and the way he captures the 'spirit of the pose'.
- Don't worry too much about drawing the detail of hands, feet and faces at first: just try to get the outlines. Focus on larger parts of the body first and if you can find some statues that don't include a head, hands and feet at all, then all the better – start simply.
- Go to a life-drawing class and try some quick drawings where you capture the spirit of a pose in a minute or two if the model is doing short poses. Move around the model and draw them from different angles if they are doing longer poses.

IDEAS FOR THE MORE CONFIDENT

- Try working in collage and cut-outs.
- Have a go at drawing people going about their day or sitting at café tables – you will often have to work quickly.
- Watch videos of dancers and acrobats on the internet and see if you can capture the dynamism of movement.
- While watching the videos, draw the moving figures without looking at the page.

Dancer at rest

Estimated time: 30 minutes
Medium: watercolour
Surface: paper
Difficulty rating: 3

You will need:
► a small sheet of watercolour paper about A4 size or a sketchbook, a medium-size round-ended brush, a fine small-pointed brush, a pot of water, a tissue, a box of watercolours with a compartmentalized palette and some scraps of watercolour paper

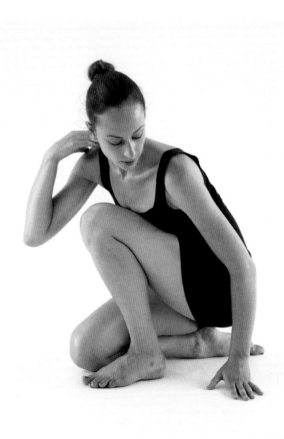

This is a quick exercise to help you to start thinking inversely when using watercolour. The idea is that you start thinking about what you need to leave out as much as what you need to put in. Here, you will 'leave out the lights', using the background paper to help create the image.

1 IDENTIFY THE TONAL AREAS

Study the image closely, and identify the major areas of dark and medium tone. Notice where the shadows fall on her body, and where the shape of her body creates darker areas.

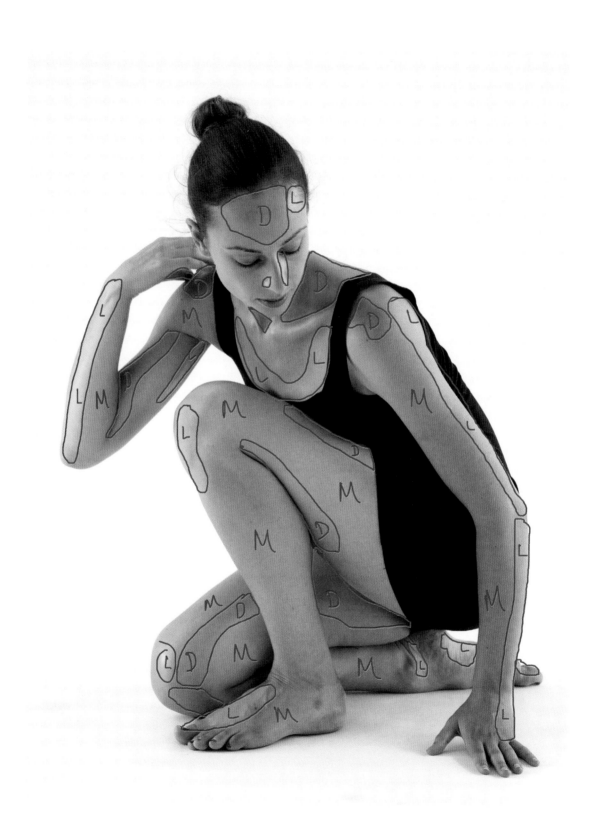

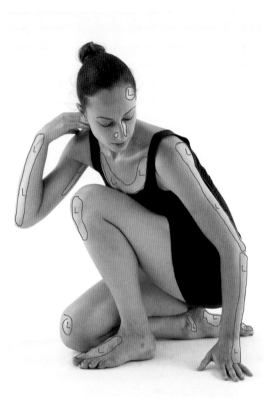

3 BEGIN PAINTING

Keep in mind the areas of light you have identified. Make sure that you don't paint anything in those areas, i.e. leave out the lights. Build up the picture gradually using thin colours to help you plan first, and then gradually add darker and darker colours when you are sure of where to put them. Remember to have scrap paper to hand to test your colours. This can help you make sure that the colours are not too dark from the start. This is only a quick exercise so have a couple of tries. You might find it takes a while to get the hang of it, but once you have mastered the technique you can use it when you are painting practically anything in watercolour.

2 PLAN THE AREAS OF LIGHT

Now identify the areas you will leave either blank, so that the light colour of the paper shows through, or the areas that only need a very thin layer of colour. These areas will sometime be quite large, like the outsides of her arms, and there will also be very small areas of light which you should try to capture.

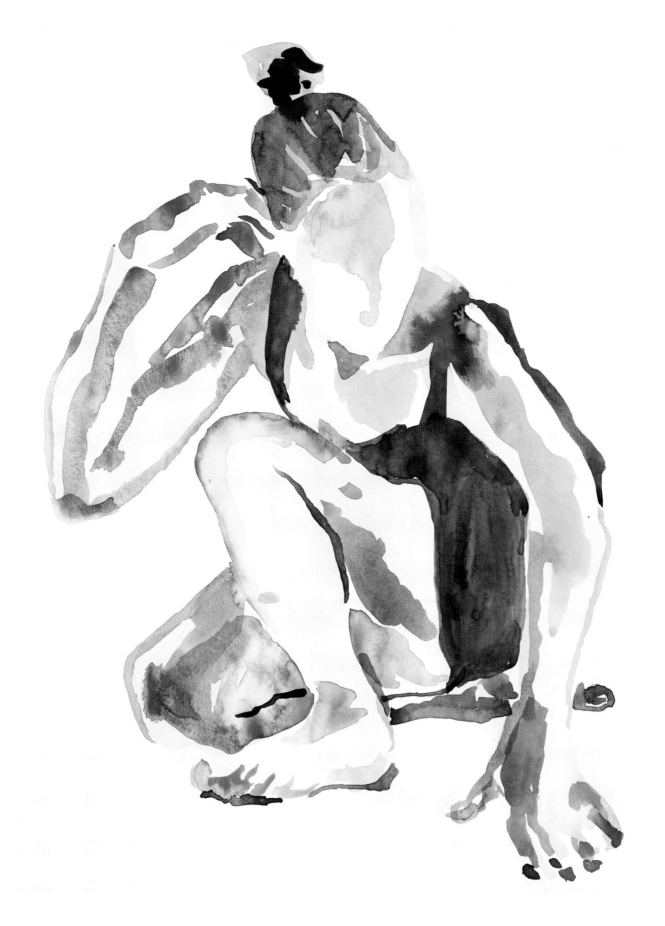

Running man

Estimated time: 3 hours
Medium: coloured pastel
Surface: white paper
Difficulty rating: 4

You will need:
► a sheet of good-quality A2 paper suitable for pastels, a stiff backing board, masking tape, a pencil, a rubber, a selection of coloured pastels, fixative spray, scrap paper for testing colours and a blending stick
► *optional:* easel

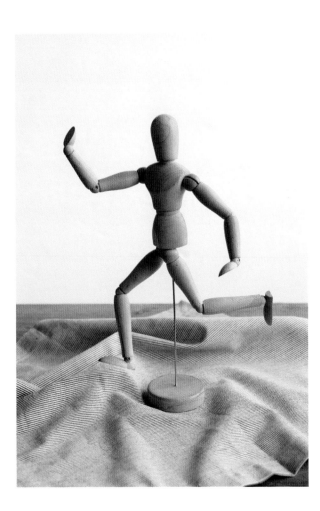

This exercise is designed to focus your mind on the lines and tones of the human form. Begin by taping your paper to the board all around the edges with the masking tape and set yourself up at your easel (or at a table if you don't have one). Make sure that you have the materials you need close at hand before you start working.

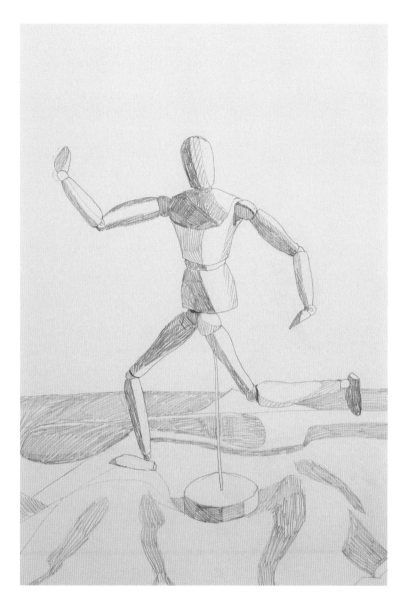

1 DRAW YOUR OUTLINE

Firstly, use your pencil to draw the outline of the figure including the stand. Also draw in the back line of the table and the outline of the napkin. Next, complete a shading plan for the figure and its stand while looking at it with squinted eyes to help you see the lights, darks and mediums. Fill them in on your drawing as best you can. Do the same for the napkin, drawing around the main areas of shadow and filling them in with pencil.

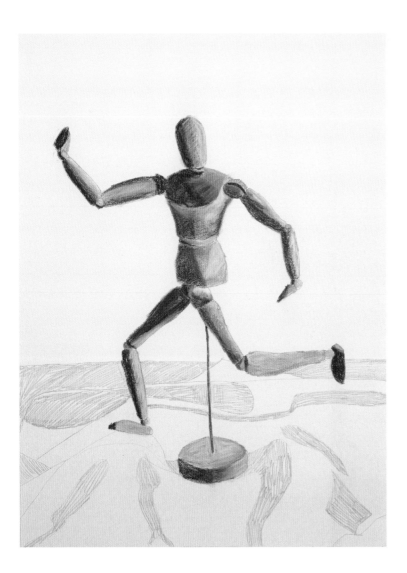

2 ADD IN COLOUR

Select some pastels from your collection to fill in the body of the man. Remember, you can use your scrap paper for testing combinations of colours before you start. To start with, you will probably need an orangey-brown, a white and a dark blue. The orangey-brown will act as your midtone for the medium areas. Depending on how bright it is, you might need to temper it down a little with white and black to make it less lurid. Adding dark blue on top of the orangey-brown will make a dark brown when blended; adding white to the orangey-brown will make a lighter version. Fill in the figure and the stand according to the shading plan that you have already completed.

3 FILL IN LIGHT BLUE AREAS

Fill in the lighter areas of the napkin with pastel. I used a combination of a light-blue pastel with some white over the top. I blended them together but not too much as I wanted to keep some of the texture of the initial stroke marks.

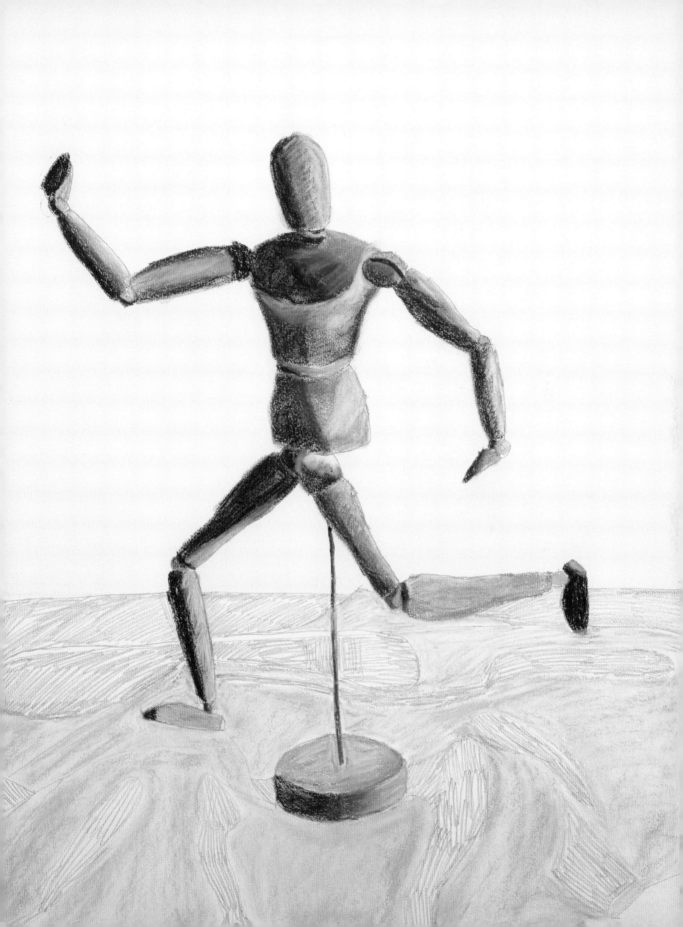

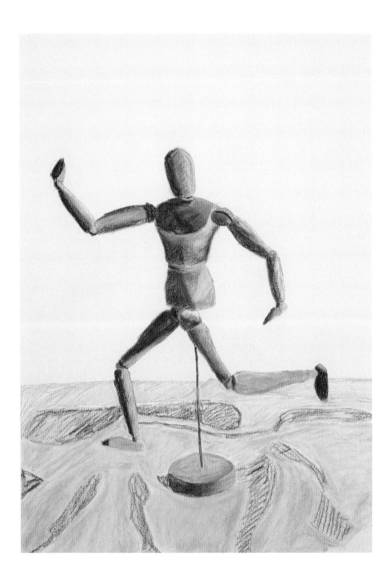

4 DARK BLUE AREAS OF NAPKIN AND TABLE FILLED IN

Choose a darker blue from your pastel collection for the shadows in the folds of the napkin and fill them in. Notice that some folds are darker than others so try to reflect this as much as you can. You can add a little white over the blue of the lighter folds if you need to lighten them.

Also fill in the table with a brown pastel, lightening it with white or darkening it with black as required: you need to get the correct tonal jump between the table and the different areas of napkin. Notice that the little triangle of table right at the front is darker than the back of the table.

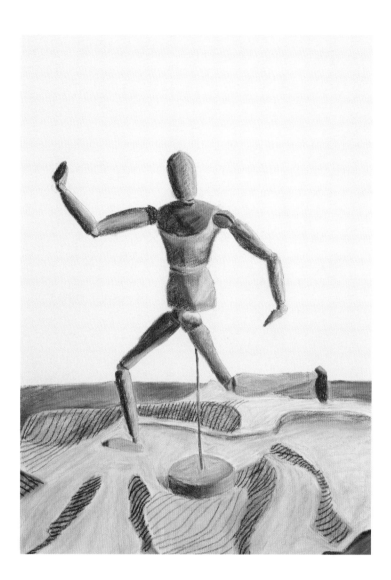

5 ADD TEXTURE

To add the striped texture of the napkin, take the darker blue pastel of the two that you have already used and start to add thin lines on top of the various blue areas. Be aware that adding lines to these areas will darken them slightly and be sure to use a sharp edge of the pastel so that you can make a very fine line. Take a good look at the initial photograph and try to follow the direction of the lines in each section of the napkin to represent the undulations of the fabric.

This can be time consuming as you have to pay close attention to the direction of the lines, which can change both within each section and between each section. Try to get the lines to meet up between sections where necessary. Just do the best you can: it doesn't have to be absolutely perfect – the stripes just add interest and texture.

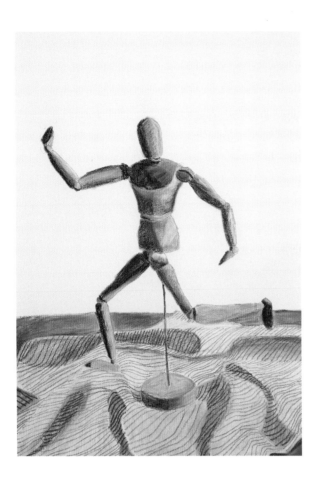

6 REFINE SHADING

After you have finished adding the lines to the napkin, look again at the shading. If you are worried that the shadows of the napkin contrast too much, at this stage you can always temper them down by adding a little white in between the stripes in the dark areas. Blend as necessary. In this instance, you will need to blend with a blending stick as opposed to your finger because the space between stripes will probably be too small.

7 FILL IN BACKGROUND

When I had finished I wasn't too keen on all the empty white space around my drawing so I decided to use some colour on the background to add interest. I could have just filled in the background with a single green, but I couldn't decide which green I liked best so I broke it up into panels and used my favourite three. When filling in a background like this, it can be helpful to test colours on the masking tape at the side to see how they look alongside the rest of the drawing.

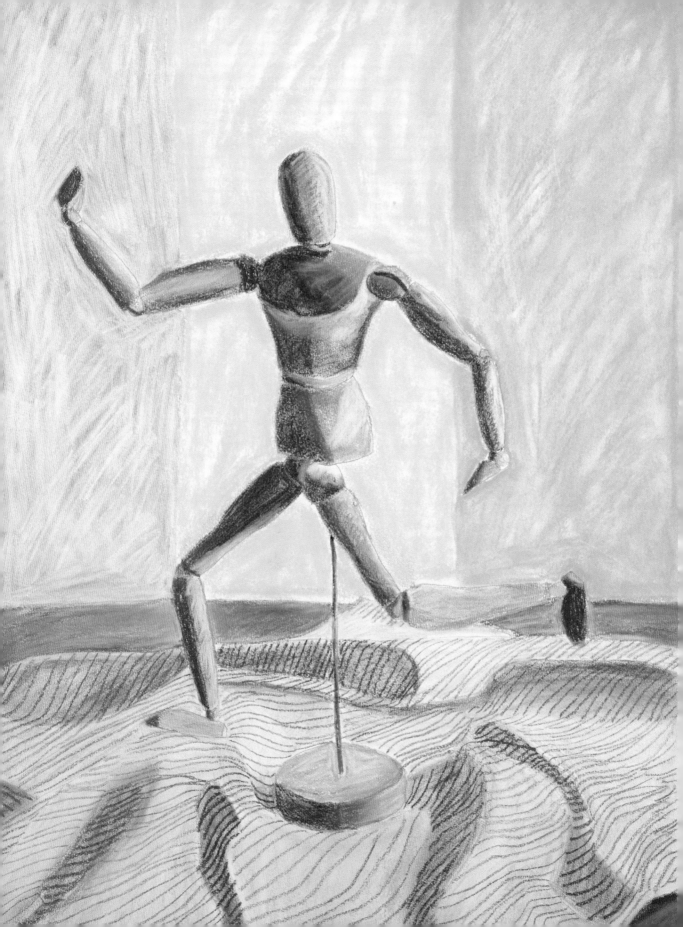

Dancer in motion

Estimated time: 1 day including drying time
Medium: acrylic
Surface: paper
Difficulty rating: 5

You will need:
- ▶ A2 sheet of watercolour paper, masking tape, a stiff backing board, a pencil, a rubber, small, medium and large round-ended watercolour brushes, a small soft-bristled pointed brush, a box of watercolours with compartmentalized palette, a pot of water, tissue or kitchen roll and scrap watercolour paper for testing colours
- ▶ *optional:* acetate and whiteboard pen

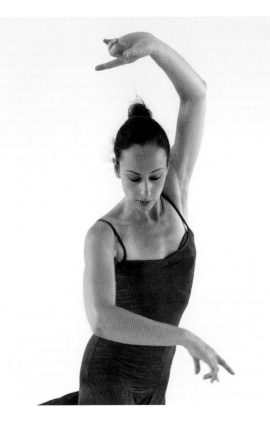

The purpose of this project is to consolidate the techniques you have learned to create a classic dancer's portrait. Begin by taping your watercolour paper to the board all around the edges. For this exercise, I advise working flat, rather than at an easel, because the watery paints may drip. Use either a table or the floor, if you don't mind painting while on your knees.

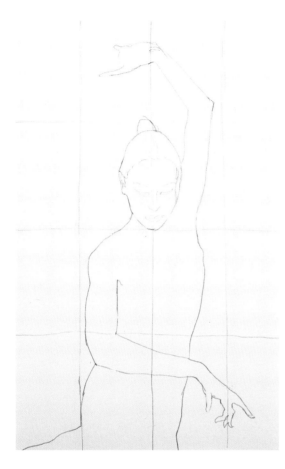

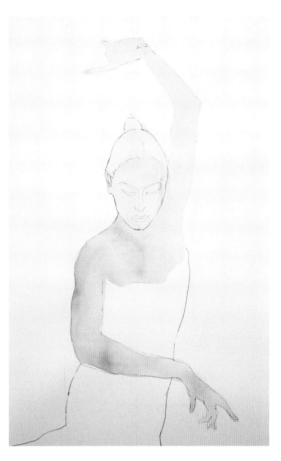

1 DRAW YOUR OUTLINE

The first thing to do is to get the outline of the figure drawn in. If you have acetate and a whiteboard pen, you can use the grid system to get an accurate outline (see page 99 for a full explanation), as I have done here. Alternatively, you can draw the grid freehand.

2 ADD LIGHTS

Using your large round-ended brush, dampen the area inside the lines of the figure using water, but do not dampen the dress. Be careful not to go over the lines or the colour that you will add next will bleed over the lines.

Look for the lightest areas of the dancer's skin on the initial photo. Mix up a warm pinky-orange skin-tone wash (a wash is a thin, watery colour) that is roughly equal to the colour of the light areas. Test your colour on the scrap paper and apply carefully with a round-ended brush.

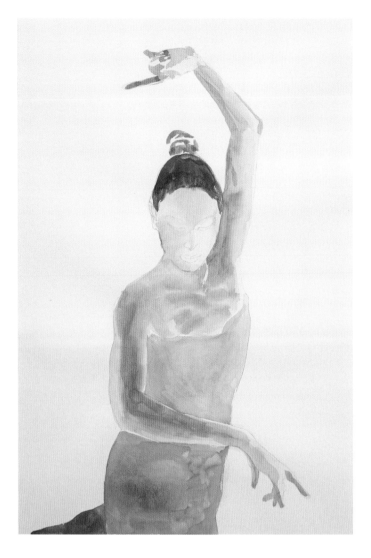

3 ADD MEDIUMS AND DARKS

While the lights are still wet, mix up some medium and dark-brown skin-tones, testing each one on the scrap paper. Add them to your picture using your large round-ended brush. You are painting wet-on-wet so the colours will bleed into each other. This is desirable in the areas where there is a smooth gradation from light to dark, such as on the front arm, the chest and the forearm of the raised arm. However, to prevent colours bleeding in the areas where there is sharp contrast, it is best to leave the paint to dry first before filling in the mediums and darks. You want crisp definition in areas such as the fingers of the front hand, the point where the raised arm meets the side of the face and all around the jawline.

In the meantime, you can add a first wash of red to the dress while being careful not to touch the wet areas on the figure.

After filling in the mediums and darks on the figure, leave the whole painting to dry.

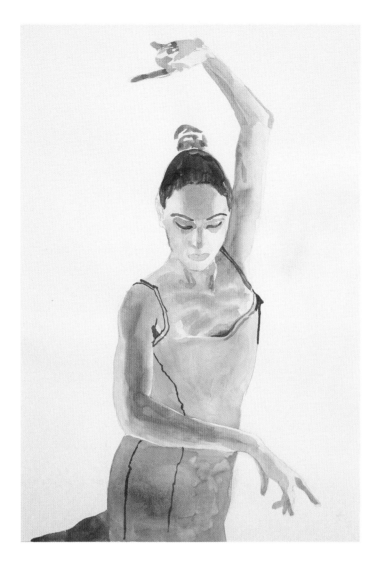

4 ADD DETAIL

Mix various medium and dark browns and blacks. Using your fine-pointed brush and a steady hand, carefully start to build up the eyes and eyebrows. Before shading the lids of the eyes, take another close look at the initial photo and notice which areas need to be left light, i.e. just above the eyelashes and just below the eyebrows.

Add a pinkish red wash to the lips. Then, building on top of the mediums that you added in the last step, start to sculpt the face by adding orangey-brown to the centre of the forehead, the bridge of the nose and the septum.

Still using a fine brush, add a little shadow to the chest and underneath the front arm with black, and start to paint in the straps and seams of the dress with a rich red.

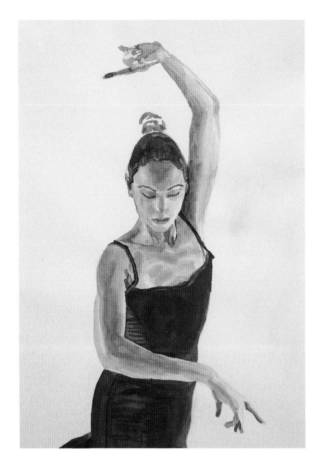

5 BUILD CONTRAST

While making sure that you do not go over any areas that need to be left light, keep on adding to the painting to darken the darks and get as much contrast into the work as you can. Look again at the areas of high contrast – such as the fingers of the front hand, under the chin and where the back arm meets the face – and darken the darks in layers until you have the correct tonal jump between dark and light. Work gradually, making sure that you have a pot of clean water and tissue at hand so that you can wash away any mistakes.

Add any finishing touches to the face as best you can but be careful not to overwork it. Faces are very easy to ruin as one wrong mark can change an expression significantly and will be difficult to correct.

Add a darker layer of red to the whole of the dress and add the shadows that the straps leave on the dancer's skin.

6 ADD BACKGROUND AND FINAL DETAIL

For variation in texture and to add a contrasting colour, I decided to colour in the background lightly with a blue water-soluble pencil. I added water to the water-soluble pencil marks with a brush. Leave the painting to dry before removing the tape from the edges.

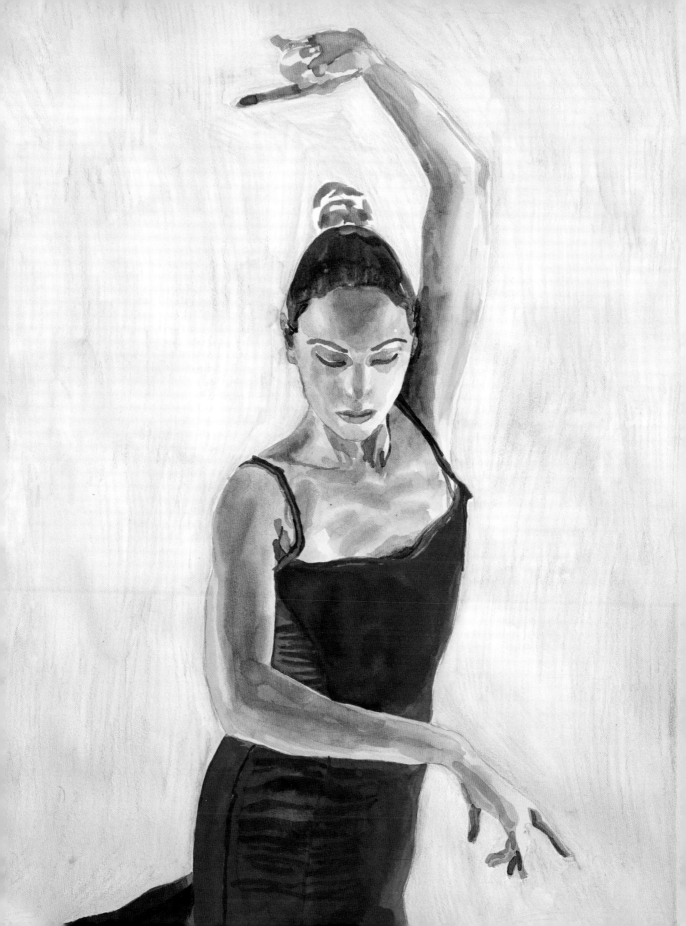

Health and Safety Notes

Most modern artist materials can be used safely with little need for protective equipment or precautions. However, it is advisable to exercise common sense and caution with unfamiliar materials. Below is a list of general safety precautions and common issues.

- Never eat or drink while working with art materials as this increases the risk of ingesting materials.
- Ensure water spills are cleaned up immediately to avoid slipping on the wet floor.
- Try to work in a room with windows that can be opened to ensure proper ventilation.
- Always read the label on your materials – this will usually contain information on safe use, responsible disposal and how long you should keep the product before replacing it.
- Rags used for solvents should always be spread out flat when unattended as scrunched up they can generate heat and become combustible. Linseed oil in combination with certain pigments can also present a risk of spontaneous combustion when left on rags, paper or other combustible materials in a confined space. Always store and dispose of used solvents rags in a fireproof container. Alternatively, soak them in water and dispose of them in a sealed bag away from other rubbish.
- Be careful to avoid inhaling or ingesting pastel dust. Rather than blowing off the pastel dust from the surface, tap the back of your drawing to get rid of the excess.
- Store all materials, particularly solvents, in tightly capped containers.
- If paint or solvents splash onto your skin, wash immediately and thoroughly with water.
- Keep all art materials out of the reach of children and animals.
- Do not expose any of your materials to heat sources or naked flames.
- Always wash your hands thoroughly after working with art materials.

ENVIRONMENTAL CONCERNS

Artists have a responsibility to the environment, given the nature of some of the materials used.

► Use only what you need – wasted materials mean more have to be made unnecessarily.

► Some solvents can be hazardous to the environment – look for the dead fish/dead tree symbol. Take extra care with these products.

► Some materials, particularly solvents, are not disposable through normal waste collection. Your local council may have a dedicated hazardous waste collection service. Always follow the instructions on the packaging of the material or contact the manufacturer.

► Highly pigmented colours and raw pigments are never entirely environmentally friendly because of the way that they are sourced and made. Never wash pigment down the sink and always dispose of it according to the manufacturer's instructions.

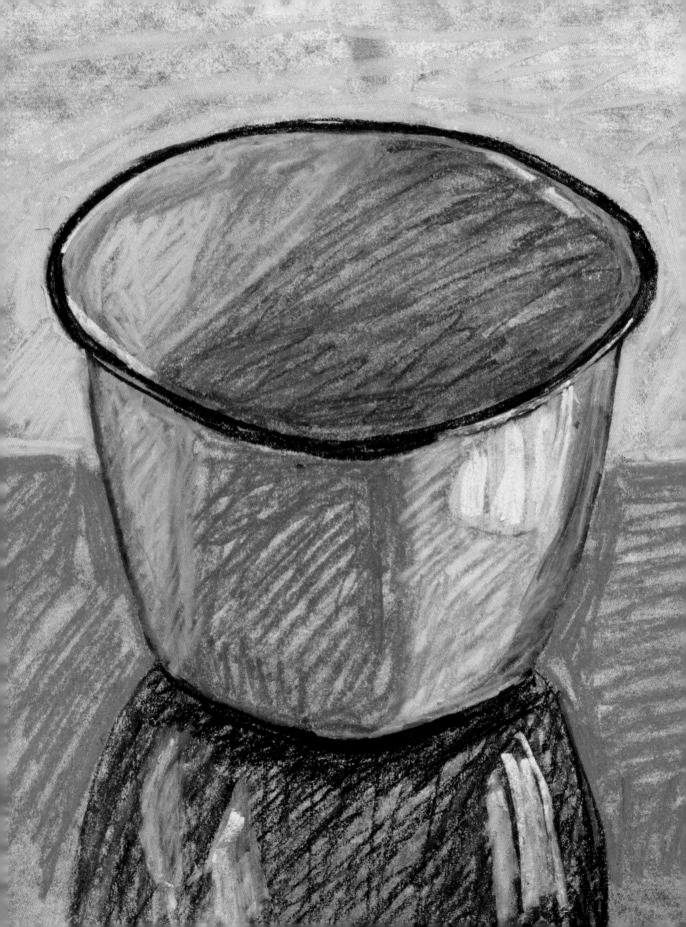

INDEX

1 3 5 7 9 10 8 6 4 2

BBC Books, an imprint of Ebury Publishing
20 Vauxhall Bridge Road,
London SW1V 2SA

BBC Books is part of the Penguin Random House group of companies whose
addresses can be found at global.penguinrandomhouse.com

Penguin
Random House
UK

This book is published to accompany the television series entitled
The Big Painting Challenge first broadcast on BBC One in 2015.

Commissioning Editor - Tom McDonald
Executive Producers - Colm Martin, Melissa Brown
Series Editor - Claire Nosworthy
Series Producer - Rob Clifford

Images on pages 101, 138, 142, 148, 162, 172, 184, 188, 194, 212 © Getty Images

First published by BBC Books in 2015

www.eburypublishing.co.uk

A CIP catalogue record for this book is available from the British Library

ISBN 9781849908962

Printed and bound in Germany by Mohn Media GmbH

Designed by Smith & Gilmour

Penguin Random House is committed to a sustainable future for our business, our readers
and our planet. This book is made from Forest Stewardship Council® certified paper.

ACKNOWLEDGEMENTS

I would like to say a massive thank you to everyone who helped me to get this book written and photographed.

Firstly, Charlotte Macdonald and Albert DePetrillo at BBC Books who have supported me every step of the way and always been there at the end of the phone with pragmatic, organized and clear suggestions. I shall miss our 45-point phone calls and having fun with you both on the shoot days, though I'm still a bit upset that my fluorescent coral shellac nails didn't manage to make it into the book!

Also, thank you so much to Sarah Cuttle, the photographer, for taking such beautiful photographs and being so lovely all the way through. Thanks for gently asking me to try and look 'a little bit less hateful' on the morning of the author-photo, which made me laugh and certainly helped me get over my discomfort in front of the camera.

Thanks to Alex, Emma, Zoë and Lisa at Smith and Gilmour for their hard work and input in helping to make the book look beautiful, and for having such a happy studio with good coffee and plentiful sweet treats to munch on at all times.

Also, I must say a huge thank you to Simon Tupper who photographed the projects with me. It was great to have your company. Don't worry, I've very nearly forgotten that you poisoned us both on day two of shooting! To Tessa Evelegh, who was so supportive and encouraging when I started Sketchout, and got me the job of this book in the first place. I probably wouldn't have done Sketchout without you repeatedly saying that you thought it was a good idea and nudging me forward when I had doubts. And to Stephanie

Villalba, who gave me my first teaching job at Chelsea Fine Arts who was so generous in sharing her knowledge and teaching talent with me and for showing me that it's possible to get by on a diet of Haribo and Twix!

And to Stella Tooth and Katie Rose Johnson, my fellow teachers at Sketchout, who have been so reliable and brilliant at sharing their passion for visual art through the Sketchout workshops. Thanks, too, to all the Sketchout clients whom we have enjoyed teaching so much and, of course, to the Victoria and Albert Museum, Tate Britain and the National Portrait Gallery who have been such graceful hosts and allowed us to work in the most amazing places in London.

I'm almost done ... but must not forget my long-suffering flatmates and loving friends Phil and Jane, who have endured me working from home most of the time. Thanks for making the Culbert Jones household such a haven of ahem ... calm and responsible wine drinking. And, of course, Ben and Jo for never being anything but generous, funny and kind to us all. And Bea for understanding my every aversion and enthusiasm with razor sharp precision and for making me laugh and cooking me such good food all the time. And lastly but not least, Mum and Dad, Et, Ames, Matt, Alice and the kiddiewinkles Luca and Nico for being my family.

Er, actually I'm still not done. I would also like to thank all my creative friends, the actors, painters, musicians, composers, filmmakers, designers and writers who inspire me everyday with their passion and fearlessness, always persevering to do the things they really want to do, even though sometimes it's really hard.

HEATHER

CLAIRE

PAUL

ANNE

RICHARD